The Professional Photographer's Management Handbook

PORTRAIT/WEDDING EDITION

by Ann K. Monteith
M. Photog., Cr., PPA Certified, A-ASP

Published by
Marathon PRESS
1500 Square Turn Blvd.
Norfolk, Nebraska 68702-0407
(800) 228-0629
Fax: (402) 371-9382
©1999

Dedication

To Charles H. "Bud" Haynes, who established management standards and
success requirements for the professional portrait/wedding studio industry.
Without his mentoring of studio owners and
business management instructors, this book would not be possible.

Published in the United States of America by

1500 Square Turn Boulevard
Norfolk, Nebraska 68702-0407

ISBN: 0-9658571-3-1

Library of Congress Cataloging-in-Publication Data: (obtaining)

Table Of Contents

Foreword

I have studied The Professional Photographer's Management Handbook *and found it to be consistent with good management practices for small businesses and accepted principles of managerial accounting. It is an outstanding resource for helping entrepreneurs in the photography industry to achieve their business goals.*

> *Ronald E. Sniegocki,*
> *Certified Public Accountant*
> *Certified Financial Planner*
> *Sniegocki & Associates*
> *Palmyra, PA 17078*
> *(800) 326-0662*

Ann Monteith is a recognized authority on the marketing and management of studio photography who serves as a teacher and private and industry-sponsored consultant to portrait/wedding studio owners. She is a widely published author on studio business management subjects and is a former chairman of the Winona International School of Professional Photography of the Professional Photographers of America (PPA). She currently serves as a member of the PPA Board of Directors. Together with her husband, Jim, she directs portraiture businesses in Annville, PA, and Deep Creek Lake, MD.

Introduction

This book was written for established professional portrait and wedding photographers as well as those who might wish to enter the field. It is based on my own experience of operating studio photography businesses in three distinctly different markets, my study of accepted studio management and marking principles, and over twenty year's experience as an instructor and consultant to hundreds of studio owners.

The business of photography is widely regarded as a "passion business," and most photographers will admit they are more interested in their passion of making beautiful images than they are in the need to make a profit. Yet without profit, a business cannot sustain itself. Experienced business people know that success comes more easily when one enters a business for the purpose of making a satisfactory return on investment rather than engaging in an enjoyable activity. Anyone who has ever pursued an expensive hobby knows how easy it is to be swept into a money pit because the activity is so enjoyable.

Almost any profitable business can trace its prosperity to a solid foundation of successful management and marketing strategies. Such business practices, like photographic principles, are disciplines that must be studied, learned, and practiced. The purpose of this book is to help you achieve the supreme satisfaction that comes from enjoying success in the technical and artistic areas of your work and in the creation of a business that will ensure long-term financial rewards.

—Ann K. Monteith

What It Takes To Succeed

's	This Month	
	Goal	**Actual**
cessory	0.00	0.00
	8,500.00	9,503.22
ssions	0.00	0.00
aits	0.00	0.00
	1,250.00	1,682.05
	8,000.00	9,229.92
	17,750.00	20,415.19
ALES	5,810.00	5,964.65
OFIT	11,940.00	14,450.54
EXPENSES		
Health Ins.	300.00	328.00
Salary	3,000.00	3,000.00
e Expense	3,600.00	3,600.00
Services	150.00	170.00
e	0.00	0.00
nce	50.00	0.00
Tax	0.00	0.00
	1,000.00	1,000.00
	150.00	169.00
g	2,515.00	1,699.00
g/Legal	0.00	0.00
nse	100.00	58.75
Expense	0.00	0.00
	0.00	0.00
ous	20.00	37.50
ense	100.00	0.00
	40.00	38.00
ssories	80.00	0.00
	150.00	156.00
n	500.00	500.00
SES	11,755.00	10,756.25
	185.00	3,694.29

Most photographers agree that the photography business is a way of life as well as a means of earning a living. Deciding to own or manage a photography business is a life-altering choice. If your interest in photography springs from a hobbyist's passion, you will need to temper that passion through the discipline of business management principles. If you are thinking of opening a photography business for fun, then you should be advised to keep photography as a hobby.

Competitive Opportunity

Before pursuing any business, you must determine if there is economic justification for establishing the business. The most important factors to consider are the size of your chosen target population base and the competitive advantage of your business concept relative to other photographic businesses.

First, you must determine if there is sufficient population within a reasonable geographic area for the type of photography you wish to pursue. How small is too small? This is a difficult question to answer, as so many variables can affect success. These include the number of competitors and their effectiveness; the strength of your marketing program; the desirability of your product; and the number of potential clients with sufficient buying power to purchase your product.

You can learn much about a potential market by interviewing local business owners who serve a target population with demographics similar to the clientele you wish you serve—particularly those whose businesses target clients with discretionary income. They can provide insight about the buying habits of their clients. Eventually, these contacts may prove valuable in forming "marketing partnerships" or "joint-venture marketing" strategies. You will learn more about this concept in Chapter 6.

To determine the relative strengths and weakness of competing businesses in your chosen market, consider hiring someone with good powers of perception and taste to have her portrait made at various competitors' businesses. Arm the shopper with a list of attributes that she can later rank when she recounts her observations of each firm's strengths and weaknesses. These items should include:

• Telephone skills in servicing the inquiry
• Friendliness and courtesy of studio staff
• Appeal of studio decor
• Quality of the photography
• Range of photographic styles offered
• Product pricing
• Length of delivery
• Quality of customer service

From these observations, you can evaluate the relative strengths and weaknesses of your proposed business. By shaping a business based on your competitive strengths, while at the same time determining ways to overcome identifiable weaknesses, you will enter into business from a position of strength.

Personal Characteristics

For many, the pride of ownership and the desire for independence are powerful motivating factors for starting a full-time or part-time business. Business owners enjoy a certain prestige in the community. A business such as photography offers exceptional opportunities for creativity and self-expression. When successful, a photography business provides financial rewards that one might not achieve as an employee working in another field.

Because business ownership does involve risk of start-up capital and is subject to market and business-cycle fluctuations, you should ask yourself some important questions before making this commitment. Affirmative answers will increase your chances of achieving success in the portrait/wedding photography industry.

• Do you possess the fundamental technical knowledge required to light and pose subjects in formal, candid, and location photographs?
• Do you understand the business of photography?
• Do you possess self-confidence?
• Are you a self-starter?
• Are you a leader?
• Are you dependable?
• Do you have a strong sense of commitment?
• Do you welcome challenges?
• Are you willing to work long hours, particularly in the early stages of your business?
• Do you live by a code of honor and integrity?
• Do you like people?
• Do you have a pleasant personality and a good physical appearance?
• Are you good at organization?
• Can you see the "big picture" as well as attend to minute detail?
• Do you have an open mind?
• Do you have a good imagination?
• Do you possess common sense?
• Are you in good health?
• Are you emotionally mature?
• Can you accept constructive criticism?
• Do you approach decision making in a business-like manner?
• Can you handle confrontations in a non-threatening manner?
• Does your family approve of your plans?
• Do you have financial and business advisors?
• Do you have adequate financing?
• Do you have a suitable place of business where you can meet with prospects and clients?

Professional Association Membership

Networking with other professionals is invaluable throughout your professional career, especially when you are launching a new business. The dominant professional association for professional portrait/wedding photographers is Professional Photographers of America (PPA), whose membership comprises both working professionals and aspiring professionals in most imaging specialties. Through membership in PPA, you have access to professional education; up-to-date information on changing technologies and other issues that have direct impact on photographic markets; specialized insurance plans; national consumer-awareness programs; and person-to-person networking with other professionals. PPA also supports over 200 national, regional, state, and local affiliates throughout the U.S. and abroad.

For membership information, contact:
Professional Photographers of America, Inc.
229 Peachtree Street
Suite 2200, International Tower
Atlanta, GA 30303
(800) 786-6277

Technical Skills and Client Service

Producing a quality product is a given for any successful photographic studio. Creating admirable photographs as an amateur doesn't correlate to success in the field of professional photography. The professional must make saleable pictures of subject matter over which he or she does not always have total control, and do so on a day-in and day-out basis. At the same time, he or she must provide clients with a high degree of customer service, which is critical for attracting and keeping clients in today's competitive market.

The history of professional photography reveals that a primary characteristic of successful businesses is their ability to adapt to change. The introduction of color film in the middle of the 20th century caused a major technical upheaval for photographers. Nearly all those who refused to learn the new technology either retired or were forced out of business by more modern competitors. Today, sizeable segments of the professional photography industry are making use of rapidly evolving digital technology, either exclusively or in some aspects of the business. For those who are planning to become professional image-makers, it is imperative to master the technical skills of traditional photography as well as understand the fundamentals of digital imaging.

Education in all aspects of traditional photography and digital imaging is available at locations throughout the country from the PPA Continuing Education System of Professional Photographers of America. Taught by working professionals, classes are offered at various skill levels. For PPA membership information and a listing of educational offerings contact PPA at (800) 786-6277.

Technical advice and information also is available through networking with major industry suppliers of equipment and materials. You can meet with representatives of these companies at professional association trade shows.

Like techniques of photographic imaging, principles of client service must be learned and practiced if a business is to be successful for the long term. You can acquire these skills through PPA marketing and management courses; at marketing classes dealing with retail sales operations, which are offered by post-secondary education institutions; and by networking with successful local retailers who share a common client profile with your targeted market.

Managerial Skills

No studio becomes or remains successful without good management. As important as quality photography is to the success of a business, business management skill is even more important. Examples abound of exceptional photographers whose businesses have failed, while less talented photographers possessing excellent business skills have flourished. You might consider hiring a business manager if you lack business skills; otherwise you must develop them. Important management skills include the following:
• People skills—handling both customers and employees.
• Financial management expertise that includes: familiarity with managerial accounting practices, which, as you will learn in Chapter 9, differ considerably from those used to compute tax liability; an ability to evaluate equipment purchases to avoid the trap of purchasing equipment and gadgets that may be personally appealing but have little commercial value to the business; and the ability to institute effective financial controls.
• Familiarity with computers and their major applications, including desk-top publishing and studio business-management software.
• The ability to develop operating procedures and time-management strategies that facilitate workflow.
• An understanding of the laws, regulations, and insurance needs that pertain to retail businesses in your local area and to the photographic industry itself, such as copyright legislation.

• The willingness to participate in community activities, which helps you to become better known in the broader community and provides valuable opportunities for networking with other professionals.

Causes of Business Failure

Any business is subject to failure, which can have devastating consequences to the owner, not only in terms of lost investment, but also as a blow to one's self-esteem and future business prospects. The failure rate of small businesses, especially during the first several years of operation, is alarming. The experience of countless small-business owners points to five primary reasons for business failure. Keeping your eye on these pitfalls will help you to succeed.

LACK OF CAPITAL — For many small businesses, investment capital is difficult to obtain. Often the would-be business owner is forced to come up with start-up funds from personal resources or through credit-card financing. Whatever the source, investment capital should be looked upon as a precious commodity and always spent wisely. Cash-starved businesses have a high rate of failure: Overinvestment in equipment, for example, can leave the new business without any funds for advertising and destined for disaster. The same is true of premature expansion. Even a successful business can fail if the owner misjudges the need to expand. This always should be dictated by the probability of gaining enough new business to justify the expansion on a purely financial basis.

The studio photography business, which tends to rely to a large extent on word-of-mouth advertising as well as on an active marketing program, usually takes several years to develop a loyal client base. That is why many photographers operate on a part-time basis, while working at a full-time job, until they are well recognized in the community and there is less risk associated with operating a full-time business.

POOR LOCATION — Fortunately for photographers, there are countless success stories of portrait/wedding businesses in widely diverse locations. Successful studios are found sharing space in the family home, in high-rise office building suites, in malls, in commercial locations, and in professional office complexes. What each has in common with the others is that the location "made sense" for the type of clientele that is served.

POOR PRODUCTS AND SERVICE — Assuming that success as an amateur photographer automatically equates to success as a professional can be a fatal flaw. Some photographers simply cannot tolerate the additional burden of creating photography on demand within the constraints of management controls and customer service.

MISJUDGING CUSTOMER NEEDS — Businesses are most likely to succeed when they find needs in the marketplace and target their products and services to fill those needs. Remember that photography falls into the "passion business" category—one in which the primary motivation is to allow the owner to pursue a product or service in which he or she takes deep personal satisfaction. Don't let your passion for a specific type or style of photography blind you to the hard realities of marketplace demand.

BAD MANAGEMENT — You may have noted that each of the issues listed above involves management. While business management may not be the first concern on the mind of a photographer who is eager to express his or her art, it is the most important factor for achieving a profitable outcome.

Good management is largely a matter of choice. You can choose to be ruled by the passion of the endeavor and face an uncertain business future, or you can choose to build a business that rests on the firm foundation of sound business-management principles, particularly those that involve money management. Begin by studying the information in this book, then take advantage of other opportunities to improve your management skills. Soon you will start to think of yourself not as a photographer, but as a business person who offers photographic services. That slight shift in self-perception will help you to remain focused on the road to success.

Developing A Business Concept

Market research assesses the need, desirability, and packaging of a product within a typical or test market. For portrait/wedding photography, need and desirability are virtually a given. It remains to be seen, however, as to what quality, style, and price is acceptable. The role of packaging also comes into play. In studio photography, "packaging" is a more complex concept than how the product will be boxed and displayed. Here, packaging pertains to the environment in which business is conducted, affecting how product value is perceived by the client. You will recognize the importance of these factors as you choose your place in the market and develop appropriate products for your clientele.

Understanding the Industry

SESSION/SALES VOLUME CATEGORIES

Most studio businesses fall into these categories:

- **High Session-Volume — Low-Price Studios:** Department store studios such as Sears and Penneys, national chains such as Olan Mills and Glamour Shots, and itinerant photographers who temporarily set up in department stores and school systems dominate this category.

- **Medium Session-Volume — Medium-Price Studios:** The majority of privately owned photographic studio fall into this category.

- **Low Session-Volume — High-Price Studios:** Only a small percentage of photographers serve primarily affluent clients.

OPERATIONAL PROFILES

Within the three sessions/sales categories, studio operational profiles vary as follows:

- **Full-Service Studios** – This profile includes both large and small studios that offer most of the

portrait/wedding specialties: general portraiture, senior photography, and wedding photography; often underclass and team photography; and sometimes commercial photography. In metropolitan areas, some studios adopt this profile in order to generate high sales volume and profits; in smaller, more isolated communities, offering such variety is an economic necessity.

- **Niche-Market Studios** – Because it can be practiced part-time, wedding photography often is an entry path to the industry. Many photographers, even when they make the transition to full-time business, continue to offer wedding services exclusively. In areas of middle to high population, some photographers practice exclusive specialties such as children's portraiture or senior portraiture, achieving competitive advantage through high visibility as well as marketing and operational simplification. Other niche services that provide part-time entry and can sustain a full-time business are underclass, teams, and activity photography.

- **Mixed Profile** – Many studios blend multi-service offerings with a special emphasis in a niche-market area such as weddings, seniors, glamour photography, and even pet photography.

TECHNOLOGY PROFILE

With its introduction in the 1990's, digital technology revolutionized professional imaging, making it possible for photographers to provide a quality product virtually on demand, with the added benefit of instant corrective and artistic manipulation. While most industry analysts agree that traditional silver-halide film technology will continue to play an important role in professional imaging, today's photographers should develop an understanding of filmless technology in order to take advantage of opportunities that could be served more efficiently by this important advancement.

Identifying Photographic Markets

Once you have identified your desired session/sales volume category, you can look for potential "market targets" in your community and define the photography products they might wish to buy. The prospects are nearly limitless. Following are some of the most obvious possibilities:

INDIVIDUAL MEN AND WOMEN

In earlier photographic history, the individual portrait was the mainstay of the profession. Men and women were photographed, in a rather literal fashion, because they could see the value of leaving behind an image of themselves to be viewed by future generations. Over the years, however, the individual portrait has declined, most likely because photographers have failed to place sufficient marketing emphasis on its importance. Opportunistic photographers can exploit this important product by stressing the many benefits—from gift-giving to home decor—as justification for having an individual portrait made. An ability to create a variety of individualized portraiture styles, ranging from classical character studies to environmental images, also will help to persuade individuals to have their portraits made. Advertisements to the lucrative older-adult market population will help to build this category.

ADULT HOBBYISTS

This market-target group is a logical extension of the individual men and women category. It is mentioned as a separate category because of specialized marketing considerations. Many adults invest large sums of money and many rewarding hours in hobbies, which are a great source of pride to them. Among these hobbyists are hunters, trap shooters, antique-auto buffs, artists, skiers, golfers, bowlers, bikers, etc. For such enthusiasts, a hobby or "special interest" portrait that shows them with hobby paraphernalia can be a source of immense pleasure.

COUPLES

Within the couples product-line category lie two distinct market targets: younger couples and older couples. The first category includes engaged couples, young lovers, or newly-marrieds—the marketing message for whom is to have a portrait made that captures a time of youth and excitement that they and their children will enjoy in future years. The second category often pertains to couples who are celebrating significant anniversaries. With an anniversary couple or any older couple, a strong marketing appeal is to their desire to provide themselves, their children and grandchildren with a lasting photographic remembrance—possibly one that portrays them involved in a favorite pastime.

BRIDAL COUPLES

The obvious need of most bridal couples is for candid wedding coverage. What is often overlooked, however, are the business and artistic possibilities of bridal portraiture. For many years, studio photographers stressed the importance of the formal bridal portrait by making brides recognize that it is the formal portraits of the bride or of the bride and groom that tend to be passed down from generation to generation, rather than informal candid wedding photographs that mean nothing to succeeding generations. Many of today's brides have bridal portraits or restored bridal portraits of their mothers and grandmothers, therefore they can understand the appeal of having a formal bridal portrait of themselves alone and with the groom.

Some couples, particularly those who are planning second weddings, appreciate creatively conceived "studio wedding" formal and informal portraits as a desirable and less-expensive alternative to candid coverage at the church and reception. For those photographers who are looking for a profitable alternative to candid wedding photography because of the demands it places on precious weekend time, studio weddings may be a good choice.

FAMILIES

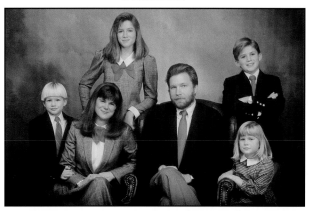

Family portraits are an excellent revenue source for photographers, since larger prints and multiple print orders often result. Family portrait sales sometimes include "family clusters" that comprise portraits of the family members as individuals as well as in groups: such as children together, mother with father, and, of course, the entire family group.

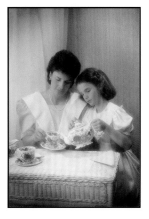

The family portrait photographer enjoys limitless opportunities for creative expression when portraying the many relationships within families: such as mother and child or children, father and child or children, and even the very special bond that exists between grandparent

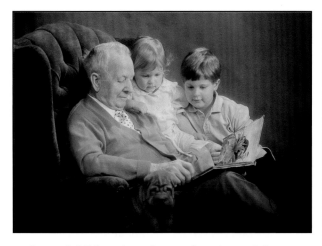

and grandchild as they share a favorite activity. Such portraits make lovely personal statements. As wall decor for the home or office, relationship portraits have great client appeal.

YOUNG FAMILIES

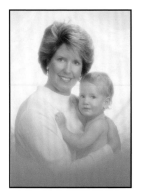

A young family becomes a market target with the arrival of a new baby. Nothing is more charming or precious to a family's history than a portrait of mother gazing adoringly at the baby or the baby being held by mother or father, or with an older brother or sister looking on. When introduced to such compelling portraiture, and treated to outstanding personalized service, a young family is likely to become a life-long client for many additional photographic products.

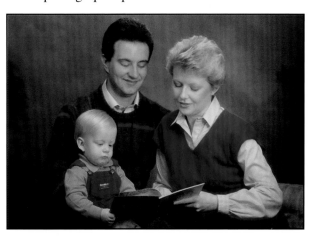

CHILDREN

Market research shows that the largest single segment in the existing portraiture market is children. In addition to enjoying the financial benefits of an on-going source of portraiture subjects, this product line also offers limitless opportunities for creativity. Whether interpreting a delicate image of a tiny baby asleep, capturing the essence of childhood in a timeless classical portrait, or portraying the child in a natural environmental setting, creative options abound for making highly marketable products for a client base that often provides repeat business.

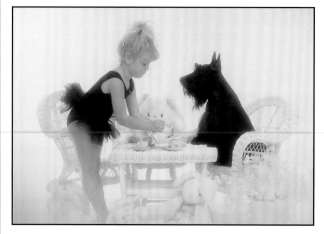

YOUNG ACHIEVERS

To the many young people who are active in athletics, musical organizations, drama, and art, or who have other interesting hobbies, a portrait depicting them engaged in the hobby or in the uniform of their favorite activity can be a particular source of pride to themselves and their families. Aim marketing efforts at Cub Scouts, Brownies, Girl and Boy Scouts, and children's athletic leagues.

Achievement also can be recognized through communion, confirmation, and bar/bat mitzvah portraits, which serve as a source of pride and remembrance to children and their families.

HIGH SCHOOL SENIORS

Senior portraiture is another field that combines good income potential with opportunities for creative expression. Senior photography is conducted both by "contract" companies, which agree to provide candid photography service at no cost to the high school yearbook in return for the opportunity of making portraits of seniors, or by non-contract photographers.

Non-contract photographers obtain business by advertising to seniors in schools that do not use a contract photographer or to seniors who are not satisfied by the quality of the contract photographer.

UNIFORMED SERVICE MEN AND WOMEN

Pride is one of the motivating factors that lead men and women into uniformed service—in the armed services, as police, or as fire fighters. A portrait of a man or woman in uniform represents a tangible expression of that pride.

EXECUTIVES, BUSINESS PEOPLE, AND PROFESSIONALS

Personal and professional image is vital to individuals in business, industry, and the professions, so these individuals represent an important market. Their needs include head-and-shoulders publicity portraits, studio portraits, and portraits made on location at the place of business.

"Interpretive" portraiture, in which the subject or subjects are depicted relating to an attractive environment, is an excellent choice for dramatic wall decor. Establishing working relationships with respected designers will result in excellent commissions that benefit your business financially and enhance your artistic reputation.

PETS

The bond between an animal and its master is sometimes as strong as human relationships. Photographers who love animals and enjoy working with them can build pet photography into a profitable specialty that can stand on its own or be offered as one of many studio portraiture product lines.

INTERIOR DESIGNERS

In their capacity as professionals who both suggest and purchase home furnishings for their clients, interior designers are an appropriate market for artistic portraiture. However, most designers must be educated about the decorative potential of fine portraiture before they are willing to recommend portraiture to their clients. Most designers receive a professional commission (usually 25-35 percent of the total sale), so your prices must reflect this additional charge. Expect to work closely with the designer and client to create a portrait or portraits that will help to unify and enhance the overall design scheme of the room in the home or office in which it will hang.

BUSINESS, INDUSTRY, GOVERNMENT, NON-PROFIT AGENCIES

Professional organizations frequently need portraits of their personnel and candids of their activities for use in illustrating newspaper and magazine articles. Target your inquiries and promotional approaches to the buyer of this photographic service. Usually this is the director of marketing, public relations, or a subordinate of one of those professionals. Occasionally the buyer is the chief operating officer, therefore he must be approached directly. Generally, it is best to reach the person in highest authority who deals with the organization's image.

Sports Teams, Activity, and School Photography

Many photographers make a good living doing nothing but team, activity, and school photography that involves creating group and/or individual photographs of:
• Middle school and high school sports teams
• Middle or high school activity groups
• High school proms and dances
• Community sports leagues
• Scouting organizations
• Schools of dance
• Nursery or pre-schools
• "Undergrads" (Elementary schools, middle schools, and high schools)

For some individuals, doing this type of photography is an ideal way to get involved in the profession without having to commit to the expense of a studio facility; and for existing studios, this product line can bolster profits without having to expand facilities.

To market your services for this type of photography, be prepared to make personal presentations—including samples of your work and pricing information—to the coach, advisor, or supervisor of the activity or school.

Restorations

The value of restored photographs as wall decor for homes and offices is appreciated by decorators and designers, as well as by most clients. There are literally billions of photographs in existence that are beginning to crack or fade, and they can be restored and reproduced for the enjoyment of present and future generations. Offering this product line is good for business and a valuable service for clients.

Expanding Photographic Markets

One of the primary causes of business failure is that the business is unable to generate enough sales to offset what it costs to do business—that is, to produce the product, pay overhead (including the owner's salary) and generate a profit. So a step-by-step plan for increasing sales is essential if you are to manage a viable business.

The most straightforward way to increase sales is to reach a broader market base. This is most easily achieved by offering products that appeal to a wide variety of the public's needs and tastes. Successful retailers know that the key to profitability is to sell more units of existing products and, whenever possible, to add new and potentially good-selling products to the mix. The same strategy applies to the business of photography.

When a photographer begins to think of each type and style of image he can make as being a specific "product," when he works to develop as many different products as he can find customers for, and when he markets each of these new products successfully, then sales are bound to grow.

Developing <u>Your</u> Business Concept

This chapter listed the various types of customers or "markets targets" that are likely to exist in the typical marketplace. This is a good place to start when developing your business concept. Review this information before you begin what will be one of the most important plans you ever make. Then you will be ready to tackle the rest of the process, which includes determining your product lines and creating a "product line inventory."

Determining Your Product Lines

Continue to develop your business concept by establishing exactly what your product lines will be. This structure is vital because it will become the foundation not only of your marketing plan, but also of the accounting records required to chart the progress of your business.

Listed below are typical portrait/wedding photography product lines, presented with sub-categories, in a manner that is appropriate for both marketing and accounting purposes.

POSSIBLE PRODUCT LINES

Studio Portraits
(portraits created in the studio camera room or in a location on the grounds of the studio itself)
Categories: Individual Men
Individual Women
Couples
Families
Children
Pets
Brides
Executives

Location Portraits
(portraits created in a location remote from the studio)
Categories: Home
Office
Other Location

Glamour Photography
(photography that includes a beauty make-over)
Categories: Head-and-Shoulders
Boudoir (includes full body)

Seniors
Categories: Studio
Location

Undergraduates
Categories: Nursery Schools
Public or Private Schools

Activities
Categories: Sports Teams (school or
community)
School Groups
Proms
Dance Schools

Weddings
Categories: Candid Wedding
Studio Wedding

Service
(black-and-white publicity portraits and passports)

Promotions
Categories: List each promotion by
name or subject matter

Commercial
Categories: Products
Public Relations
Location

Restorations
Categories: Family Wall
Family Album

Wall Decor
(nature, landscapes, graphics)

Frames and Accessories
(frames and accessories sold by themselves—not sold in conjunction with a specific product line)

CREATING YOUR PRODUCT LINE INVENTORY

Through the process of "Product Line Analysis" you can determine—for each product/category—how many different styles or treatments of the subject matter you can or wish to compose. What you accomplish in doing so is to create a virtual "inventory" of all the sales possibilities existing within each product line. This tells you precisely what you have to sell to the public. As your business grows, you adapt it to change by seeking untapped markets, formulating different approaches to existing markets, and creating additional products for existing and untapped markets. That's why this process (and understanding your products) is so important.

Study the sample "Product Line Inventory List" sheets on pages 19 and 20. They analyze categories under the Studio Portraits product line. Here, you enumerate—under the "Product" heading—every possible style of portrait you intend to sell within the specific category. Your goal, then, is to make samples of each of these "products." Doing so helps to expand the vision of your clients and reminds you of the many image possibilities that can add variety to your look.

Note that the inventory list also includes a column heading of "Buyer." This information will be helpful when you start to develop promotional plans. It serves as a reminder of the various categories of buyers your promotions must reach, and you will see how this designation is used for promotional planning in Chapter 6. Whether you are just starting your business or have been in business for many years, completing an inventory for each category of your product lines will help you to better understand your business and to take charge of its future direction.

Product Line Inventory List		Product Line _Studio Portraits_		
Category	Buyer	Product	Sample Available	Sample To Be Made
Individual Men	• The man himself (usually for use as a gift) • The woman in the man's life (usually for her own use) • The man's business (for professional use)	• Conventional head-and-shoulders poses • Head-and-shoulders character study • Three-quarter-length studio formal • Three-quarter-length studio informal • Outdoor location portrait • Indoor location portrait • Special interest portrait involving the man's car, motorcycle, pet, hobby, sports activity, etc.	X X X X X X X	
Individual Women	• The woman herself (usually for use as a gift) • The man in the woman's life (usually for his own use) • The woman's business (for professional use)	• Conventional head-and-shoulders poses • Head-and-shoulders glamour study • Three-quarter-length studio formal • Three-quarter-length studio informal • Studio window-light portrait • Boudoir portrait • Studio hi-key portrait • Outdoor location portrait • Indoor location portrait • Special interest portrait involving woman's car, pet, hobby, sports activity, etc.	X X X X X X X X X X	
Couples	• Engaged couples • Young married couples • Anniversary couples • Children of older couples	• Conventional head-and-shoulders • Head-and-shoulders "mood poses" • Three-quarter-length studio formals • Three-quarter-length studio informals • "Intimate" portraits • Outdoor location portraits • Indoor location portraits • Special interest portraits involving couple's car, motorcycle, pet, hobby, sports activity, etc.	X X X X X X X	

The Product Line Analysis process, shown here and on page 20, helps you to determine what type and style of portraits you wish to sell to clients; what clients are likely to purchase the products; what product samples you have on hand; and what samples you need to make. By reviewing the completed inventory from time to time, you are reminded that making a variety of images and marketing them to the public helps to refresh your creative side, while at the same time reaching new clients.

Product Line Inventory List		Product Line _Studio Portraits_		
Category	Buyer	Product	Sample Available	Sample To Be Made
Families	• Family member (usually the wife for personal or gift use) • Parents of the husband or wife (for their own use or for a gift to their children or grandchildren) • Close friends of the family for use as a gift to the family	• Three-quarter-length studio portrait • Full-length formal studio portrait • Full-length informal studio portrait • Hi-key studio portrait • Outdoor "garden" location portrait • Outdoor "rustic" location portrait • Outdoor "woodland" location portrait • "Relationship" portraits including • Mother and baby • Mother, father and baby • Mother and child or children • Father and child or children • Grandparent with grandchild or grandchildren • Siblings • Special interest portraits with favorite activity	X X X X X X X X X X X X X X	
Pets	• Pet owners • Pet professionals (vets, dog and cat groomers) • Friends of pet owners (for use as a gift)	• Head-and-shoulders poses • Full-length pose of single animal • Full-length pose of two or more animals • Portrait of puppies or kittens	X X X X	
Executives	• Executive's company • Executive's family	• Conventional head-and-shoulders poses • Head-and-shoulders character study • Three-quarter-length formal studio portrait • Location portrait in office • Location portraits in miscellaneous work places	X X X X X	

The Product Line Inventory Lists shown here and on page 19 were created using a computer graphics program. Today, this time-consuming process is greatly simplified through automated software. As you see from the computer window shown below, a pop-up menu of the various Product Line Analysis topics prompts you to make the appropriate entries. A report is then compiled and can be printed. This information also is available to the software's marketing plan, and can be used in completing your product line promotional plan.

Product Line Inventory List		Product Line *Studio Portraits*		
Category	**Buyer**	**Product**	Sample Available	Sample To Be Made
Children	• Parents of child • Grandparents of child • Friends of child's parents (for use as gift)	• Head-and-shoulders (including profile) poses • Three-quarter-length formal low-key in studio • Full-length formal low-key in studio • Three-quarter-length informal low-key in studio • Full-length informal low-key in studio • Three-quarter-length formal hi-key in studio • Full-length formal hi-key studio portrait • Three-quarter-length informal hi-key in studio • Full-length informal hi-key in studio • Head-and-shoulders portrait of two children • Head-and-shoulders portrait of three or more • "Interpretive" study (engaged in activity) • Outdoor location portrait • Indoor location portrait • Special interest (with pet, hobby, or sports • "Milestone" (bar mitzvah, communion)	X X X X X X X X X X X X X X X X	
Bridals	• Bride • Bride and groom • Parents of bride and groom • Members of wedding party • Family members	• Low-key head-and-shoulders of bride (groom) • Hi-key head-and-shoulders of bride • Three-quarter-length low-key of bride (groom) • Three-quarter-length high-key of bride • Full-length low-key of bride • Full-length hi-key of bride • Close-up of bride with candles • Window-light portrait of bride • Outdoor location portrait of bride (groom) • Indoor location portrait of bride (groom) • Low-key head-and-shoulders of bride & groom • Hi-key head-and-shoulders of bride & groom • Three-quarter-length low-key of bride & groom • Close-up of bride & groom with candles • Window-light portrait of bride & groom • Outdoor location portrait of bride & groom • Indoor location of bride & groom	X X X X X X X X X X X X X X X X	

Source: SuccessWare (800-593-3767)

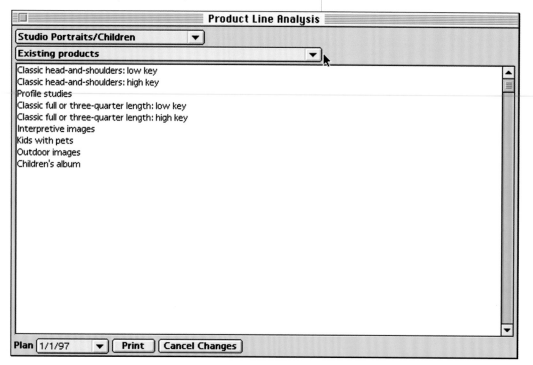

Choosing A Business Location

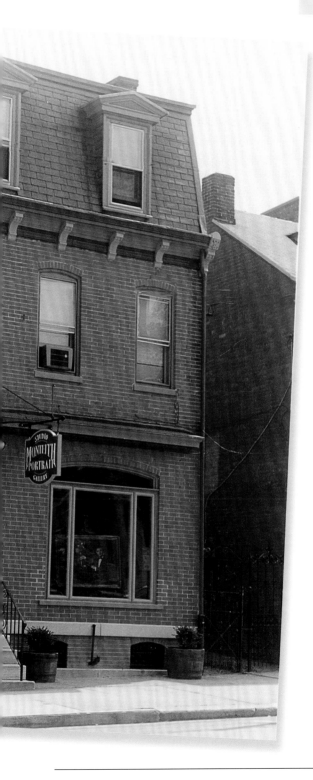

*T*he location or relocation of your business is one of the most important decisions you will make. Location affects nearly all aspects of business, including clientele, hiring and keeping employees, production costs, marketing plans, and perhaps even the quality of the photography that can be produced there. Planning a business location or relocation should be done so that all of the location's characteristics work in favor of the business. This chapter spells out the advantages and disadvantages of various business location possibilities. The issues raised should dictate whether you decide to work in your home or at a commercial location; establish your business in an inner city or closer to an area that supports activities enjoyed by your family; or choose a suburban location that is pleasant for family living and convenient to adjacent suburban populations.

The Selection Process

The following three-step process will help you to chose an appropriate location for your business:
- Select the geographical location—the town or city.
- Select the area of the town or city in which you would prefer to operate your business.
- Select the actual site within the chosen area.

Business Location Considerations

Just because you live in a certain area does not mean that doing business there is a wise decision. Among the many factors that affect where a photographer chooses to establish a business location are the characteristics of the desired target market; proximity to this ideal clientele; the population density of the desired clientele; the relative stability of the area's business base; whether the local population is growing or declining;

the photographer's financial position; the lifestyle of his or her family; the photographer's level of experience; and the nature of local competition for the targeted clientele. The ultimate decision should be based on thorough research into the needs of your target market and a realistic assessment of your ability to fulfill those needs.

Business Site Considerations

Choosing the actual building where you will conduct business can be tricky, in that you must strike a balance between finding a site that is accessible to your desired clientele and choosing one that is affordable. Factors to consider include traffic flow; availability of parking; appeal of the physical facility—particularly in relation to that of competitors; delivery access; ease of access for people with disabilities; window display possibilities; types of nearby businesses; previous ownership or rental history of the site; potential for future growth; utilities and services available; local taxes and ordinances such as signage; and the nature of the purchase or lease agreement.

When choosing a site, it is important to think about the future, particularly if you decide to purchase a building. Ask yourself if the location is likely to be satisfactory ten years in the future, and whether the building will be easy to sell for purposes other than as a photography studio.

Operating a Business at Home

Since many photographers—particularly wedding photographers—start out by working part-time, a home-studio location allows them to gain experience without making a large capital investment or incurring high overhead expense. Many continue to work at home throughout their careers. There are numerous advantages to operating a business at home, not the least of which is the aforementioned savings in start-up investment and general expenses. This helps to lessen the risk of going into business. In addition to allowing the photographer to gain valuable experience while earning a regular paycheck from another source, a business at home can, in some cases, eliminate problems of child care for the proprietors.

There are, however, some disadvantages to this business arrangement. A home business can encroach physically on family space, and it is more difficult to enforce regular business hours, sometimes leaving the owner with a feeling of being "on call" at all hours. A home location can hinder business development if it is hard for prospective clients to find, or if the home itself does not present an image that is compatible with the targeted clientele.

If you choose the option of a home-studio, you must define what percentage of your home is living space and what percentage is used by the business. This will become important when calculating business expenses. You are entitled to deduct as business expenses the established percentage of utilities, property tax, and insurance payments for the portion of your home used exclusively for business. In addition, you should calculate depreciation on any business improvements made to your property and have your business make monthly rental payments to you as the landlord. Paying rent to yourself is one of the most important things you do to establish yourself as a bona fide business entity. Without having to cover rental payments, you can charge less for your product; but your prices will not reflect the true cost of doing business. Prices will be unrealistically low, and this can be very dangerous. What would happen, for instance, if you had to vacate your home-studio because of property damage? You would be forced to find another location and pay rent to a landlord other than yourself, and you would have to raise your prices immediately to reflect the cost of doing business at the new location.

Another way to look at paying rent to yourself is to consider the space your business uses as a commercial asset. If your business did not occupy the space, you could rent it to someone else. So when you don't pay rent for the space you no longer use for yourself and your family, you are cheating yourself. Also keep in mind that all monies paid to you as rent are not classified as "earned income" and are free of Social Security and unemployment compensation taxes.

A Gracious Home Studio
Jim Romine - Lilburn, GA

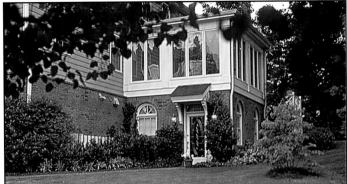

Jim Romine's Photographic Excellence studio, located in the basement of his home, was designed to overcome the usual difficulties associated with working at home. An outside entrance to a new wing addition preserves privacy for the family, and the beautifully decorated reception/sales room housed in the addition is a perfect environment for clients. Because the home is located in an appealing residential area, the adjacent grounds are attractively planted, and the interior so nicely designed and decorated, this home-studio reflects an appropriate image for the clientele that the business serves. The arrangement supplies plenty of space for day-to-day operations, all within the confines of a typical basement area.

```
┌──────────────┬──────────────────┐
│              │   Office/         │
│              │   Production      │
│              │   Area            │
│              │   10' x 16'       │
│              ├──────────────────┤
│  Camera Room │                   │
│  30' x 14'   │   Props Room      │
│              │   10' x 7'        │
│              ├──────────┬────────┤
│              │  Dressing│        │
│              │  Room    │ Reception/│
│              │  10' x 7'│ Sales Room│
│              ├──────────┤ 14' x 16'│
│              │  Hallway │        │
│              │          │        │
└──────────────┴──────────┴────────┘
                         Walk-way
                         Entrance
```

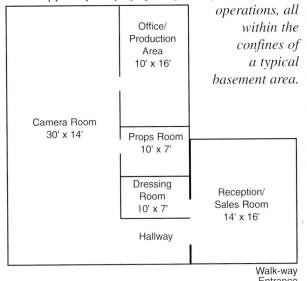

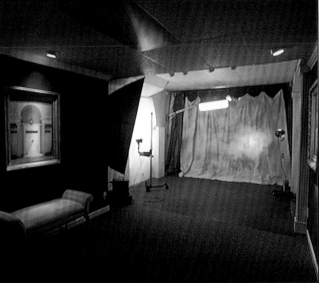

Choosing a Commercial Location

Operating a studio at a commercial location provides increased visibility in the market and gives the owner more options in terms of business growth and community image. The commercial location possibilities include leasing a commercial property, purchasing a commercial space, buying an existing studio facility, or building a new studio from scratch. The investment needed for each of these options varies considerably, and each carries advantages and risks. What most photographers who previously worked out of a home-studio discover when they make the move to a commercial location is that the higher overhead cannot be sustained by the current level of income; consequently they must employ more aggressive marketing to attract additional customers, or expand their business to include other product lines. This increased level of business usually means adding one or more additional staff members which, of course, increases overhead expense.

Before making any part-time or full-time business move that will involve commitment of capital, consult several financial management experts who understand the requirements of small business. Local business people of good standing, particularly those who operate businesses that compete for the discretionary dollar, can be helpful. A small-business consultant is a possibility, but your best bet is to hire a photographer who has a long-term track record of financial success to advise you on all aspects of your business plan. Do not sign anything that commits you to a building lease or a purchase arrangement until a lawyer studies the agreement and makes certain you can fulfill the legal obligations of business ownership such as license fees, occupancy permits, zoning variances, etc.

It bears repeating that when a home-studio photographer makes the move to a purchased or leased business facility, he or she is making a serious commitment that nearly always results in lifestyle changes. The additional expense of the new facility requires more sales to support it, and this fact inevitably means more hours on the job. Before you make your move, be certain that you not only have the potential to increase your earnings, but also that you can handle the added stress of managing a bigger business. Otherwise, you could fall victim to financial calamity or business burn-out.

Commercial Location Options

LEASING SPACE IN A COMMERCIAL BUILDING

This option offers the advantages of tying up the least amount of capital and providing many location possibilities. If your space requirements are likely to change in the near future, you should think about leasing. You might consider space in a small strip mall, the ground floor of a downtown building, an office in an industrial park, or a main street bungalow that has been rezoned as commercial property. The possibilities are virtually limitless. When leasing, you need to answer the following questions:

- What improvements will the landlord provide? A landlord eager for a tenant is more likely to be generous with improvements. After you have signed a lease agreement, it is too late to negotiate for improvements, so take care of this up front. Agreed-to improvements should be detailed in the lease.
- What services will the landlord provide? Again, you should negotiate for services such as utilities, cleaning, trash removal, maintenance, etc. prior to signing the lease agreement. These services should also be spelled out on paper.
- What is the length of the lease? Is the duration short enough to protect your position in the event of business failure, and is it flexible enough to allow you to renew? Is eventual purchase of the property possible?
- What stipulations exist if the property isn't ready when the landlord says it will be? A penalty clause will help to protect you, but it is always wise to allow several months of leeway in your occupancy planning.
- How much is the rent? Determine if there are any escalator clauses that will cause your rent to rise after a certain length of time or after you achieve a certain level of gross sales.
- Can you sublease? You may not need all the space you rent, and it will help to defray expenses if you can sublet to another tenant.
- Are you protected if your landlord goes broke?

The lease should protect you from assuming any of the landlord's debts in the event of his bankruptcy.

- Do you have adequate insurance coverage? The landlord certainly should have the building insured, but it is unlikely that he will provide coverage for your contents. Make sure you are covered from the day you move in.

Buying a Commercial Building

Owning your building will tie up more cash and involves greater risk, but if you buy the right property and make a success of your business, you will be adding an asset to your net worth that is likely to appreciate over the years and provide you with retirement income when you sell the business. Location is a key factor. The site should be reasonably accessible to the clientele you intend to serve. The building itself and the neighborhood should reflect a positive business image. Other important considerations are:

- Is the building in good condition? You must consider the purchase price in light of any needed structural improvements such as roof, carpentry, plumbing, wiring, heating, and cooling.
- What about routine maintenance and utility costs? The ideal building will be both energy-efficient and easy to maintain. Also consider the extent of routine maintenance such as snow removal and lawn and shrubbery work.
- Is the neighborhood on the decline or on the rise? You probably will find the best real estate bargains on the fringes of areas undergoing revitalization. Choose an area that is not likely to be invaded by adult book stores or the like.
- Do you know of any contemplated changes in zoning that might adversely affect your business? Check this out with the local planning commission.
- Is the property large enough to accommodate future expansion? Look to second floor, attic, and cellar space as possibilities for future expansion.
- Does the property offer any opportunities for tenant rentals? If the property contains second floor apartments, or if apartments could be added at little expense, they can provide additional income to offset the building mortgage. And if the need for expansion arises, you will have the extra room when the tenant lease expires.

Buying an Existing Studio

The most obvious benefit of buying an existing photography business is that it is already established. Such a strategy is particularly appropriate if you are an older buyer who does not want to invest years in the business-building process. You should realize, however, that buying an existing business has many pitfalls, not the least of which is there is no scientific method of arriving at the true market value of a photography business. Some rules of thumb suggest from one-quarter to one-half of recent annual gross sales, while others suggest three to five times net profit. These measures can be misleading because it is so easy to manipulate figures. Some experts suggest that the price should be one you can pay off in a reasonable length of time, say between five and eight years. In actuality, you should consider both book value and market value as well as many other factors when it comes to determining a fair price. Always keep in mind that no formula can replace good judgement in arriving at the price for a business. Other important considerations are:

- Does the business enjoy a good reputation? Don't rely on what you might know about the business from your perspective as a photographer. Ask the man on the street and local business owners. This is vitally important, because sometimes it is impossible for a new owner to overcome the bad reputation established by the previous owner.
- What is the financial condition of the business? Does the business show consistent profitability? Is the business-volume trend increasing or decreasing? Is the profit-to-investment ratio satisfactory? Retain the services of an accountant to audit all business records, financial reports, IRS returns, and depreciation schedules to determine if they are complete and adhere to accepted accounting guidelines. If the owner is not willing to let you see all of his financial statements, then he probably has something to hide. If his financial records are mess, chances are his business is a mess, too. If he claims that the records do not reflect the true scope of the business, then he is lying to the IRS and he probably will lie to you.
- Are there other photographers in the area? Does the owner enjoy cordial relationships with them?

A Center-City Gallery/Studio
Jim & Ann Monteith - Lancaster, Pennsylvania

The Monteith Portrait Studio & Gallery, formerly located in the restored city center of Lancaster, Pennsylvania, illustrates how a small space can be used efficiently for a studio facility. The first floor of the turn-of-the-century town house was renovated to include a gallery space, consultation room, production room, camera room, and restroom/dressing room (see diagram below). Two rental apartment units that occupy the second and third floors provided income that helped to offset the building's mortgage.

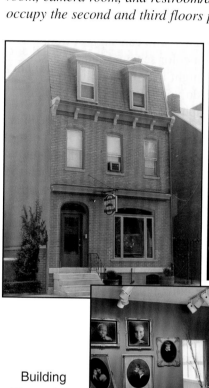

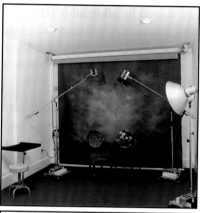

Building
Dimensions
25' x 75'

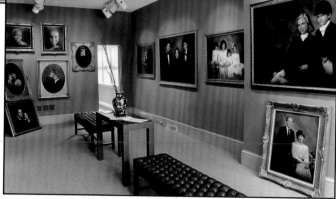

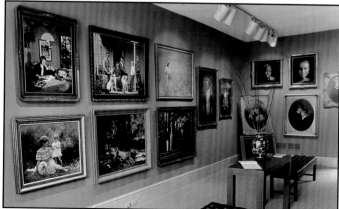

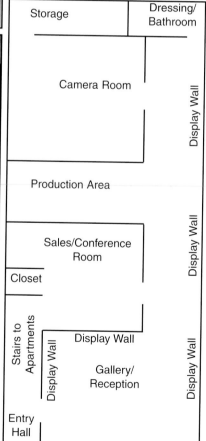

A Conveniently Located Satellite Studio
Sirlin Studios - Sacramento, California

When Ted Sirlin sold his downtown studio as part of a move to a new 9,000 sq. ft. facility, he was concerned that the new studio remodeling might take longer than he would want to have his business shut down. So he decided to open a 2,000 sq. ft. studio, in an upscale area where many of his clients lived, to keep business open during the interim period. Business at the satellite location grew so fast that Sirlin kept the facility open for seven years! The well-designed space featured portraiture displayed as part of furniture groupings to show clients its many decorative possibilities.

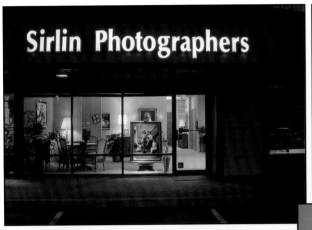
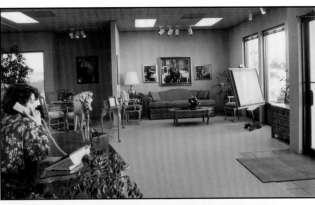
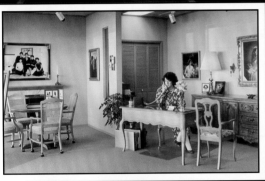

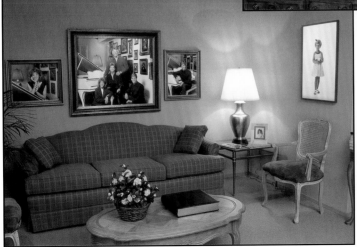
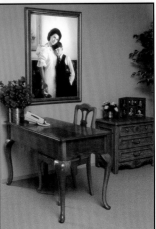

A Studio Especially for Kids
Angela Carson Photography - Northville, Michigan

Because infants and children represent the majority of Angela Carson's clients, her studio is fully equipped and thoughtfully appointed to serve children and their parents comfortably and efficiently. A second-floor hallway serves as a space where children can watch videos or play with toys from the toy box. Because props are a necessary part of children's photography, Angela has organized her many props behind muslin backgrounds, so the camera room can remain uncluttered during photography sessions. A closet conceals small "attention getters" that are so important in coaxing smiles from children, and a changing table in the dressing room is another touch of hospitality that lets parents know their young children are valued clients.

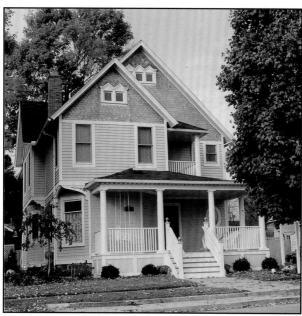

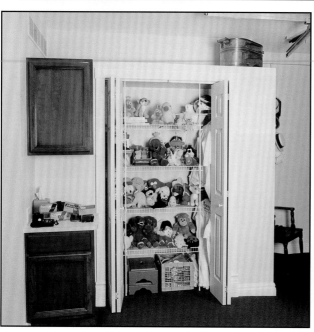

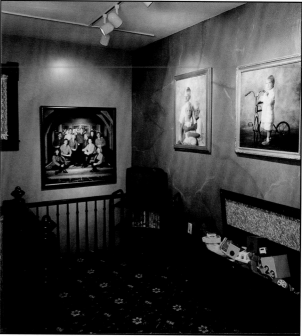

A Spectacular Senior Studio
Larry Peters - Dublin, Ohio

One of three studios operated by Larry Peters in the Columbus, Ohio, area, the Dublin location was built with high school seniors especially in mind. The "soda shop" theme makes an inviting reception area, and sales rooms are specially designed to make the most of senior sales. Several well-equipped camera rooms allow Peters and his staff to provide seniors with a variety of poses quickly and creatively, in an environment the seniors enjoy. The shooting areas include a window-lighted high-key room and an outdoor studio that features a variety of natural settings.

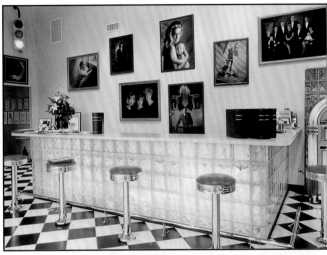

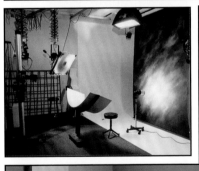

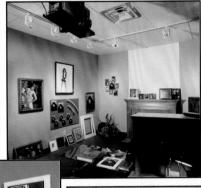

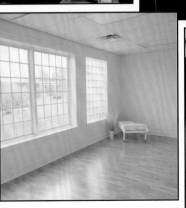

A Loft-Studio Co-op
Carol Andrews, David Jones, Nikky Lawell, Mitch Daniels - Houston, Texas

For four Houston photographers in search of a business location, a north-light loft studio in a downtown artists' complex was the perfect choice. Because the photographers practice different photographic specialities, the cooperative arrangement works perfectly. Portrait photographer Carol Andrews, wedding photographers David Jones and Nikky Lawell, and videographer Mitch Daniels share both the facilities and the overhead costs. The north-light camera room, decorated by Carol to provide a variety of backgrounds, and a preview-projection area, are the heart of the facility. Separate entrances and reception areas allow the photographers to preserve individual identity and autonomy.

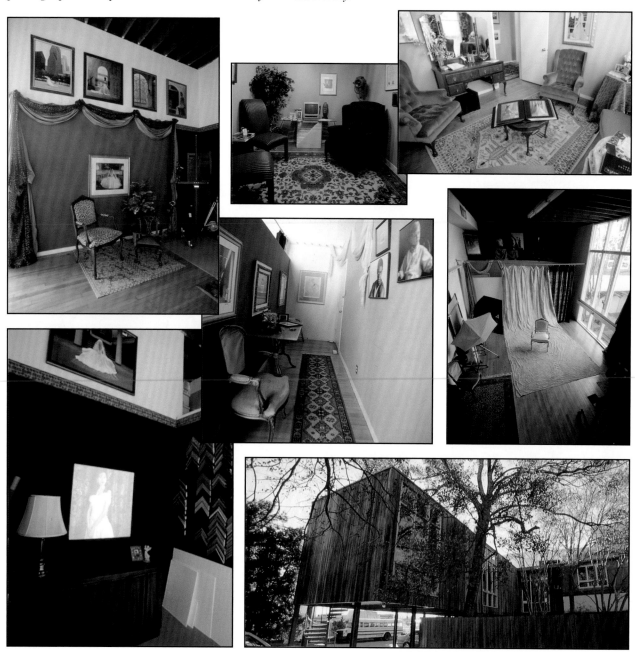

Establishing A Business Image

The image of a business is directly affected by what the public thinks of the products, owner, employees, facilities, prices, service, marketing, public relations, community involvement, and ethics of the business. A good business image is not only one of a studio owner's most important assets, it is crucial to his business success. A good image allows the business to be perceived as "successful," and that perceived success in turn creates both a demand for its services and persuades the buyer to pay more for these services. In other words, the client's "perceived value" of the product is closely tied to the image of the business.

How is an Image Built?

One often thinks of "image" as something a business builds over time. Public perception about a business does indeed build as consumers learn more about it through advertising, public relations, word-of-mouth, and direct experience. Public perception has a much better chance of working in favor of your business if you learn how to use specific image-enhancement tools to establish a well-defined presence from the very beginning of your business. Many of these tools can be in place from the day you open, and the better you use them, the better all of your marketing strategies and promotional efforts will work to gain and retain clients and to sell products profitably.

Image-Enhancement Tools

The image-enhancement tools we will survey function to give recognizable form to the business concept you wish to convey to prospective clients.

STUDIO IDENTITY: BUSINESS NAME, SLOGANS, LOGO

Your studio name and how you express its identity in the form of a logo, slogans and/or tag lines are critical

recognition factors for clients. Good business names and logos are designed to create awareness on the part of prospective clients in these important areas:
• What you do
• Where you are located
• Your position in the market

Lending your name to the business is appropriate when you wish to be tied closely to the product; but you should also consider that it will be easier to transfer ownership some day when you choose a name that is less specific to you personally.

The following business names facilitate awareness by telling prospects precisely what the business offers:

Wedding Photography by John Smith
Martha Jones Wedding Photography
Main Street Photography Studio

Additional descriptive "tag lines" or slogans facilitate awareness by locating, informing, or positioning the business.

Smith Photography Studio
 —*On the square in historic Centerville*

Jones Portrait Studio
 — *Exceptional Photography*

Jones Photography Studio
 — *Exceptional Lifestyle Portraiture*

Jones Photography
 — *Classic and Lifestyle Portraiture*

Elegance Photography
 — *Exclusive Wedding Coverage and Fine Portrait Studies*

Jones Photography Studio
 — *Preserving Family Memories for Three Generations*

A good business logo will create a "look" for your business and perhaps even convey something about your business style or concept. The services of a design professional can be invaluable in creating a logo—one that can be manipulated for a variety of uses. Make sure the designer understands your business concept and the type of clientele you are seeking to impress. Also explain any unique features about your business that might be translated into a graphic presentation of your logo.

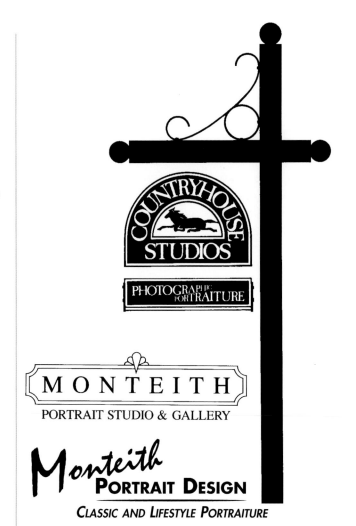

Logos should reflect the type of businesses they represent. These example show three different logos used by the author in three different businesses. The top logo was drawn from the business sign that fronts Countryhouse Studios in rural Annville, Pennsylvania. The middle logo was created for a carriage-trade location in downtown Lancaster, Pennsylvania. The bottom logo was designed to attract upscale clients in the four-seasons resort area of Deep Creek Lake, Maryland.

The stationery items shown at right were laser-printed on high-quality predesigned papers that allow the business to create a custom-designed look at an affordable cost.

Elegance Collection stationery source:
Marathon Press (800-228-0629)

STUDIO STATIONERY AND BUSINESS CARD

As an important means of communicating with clients, studio stationery should incorporate your logo and any other elements that will visually and verbally support your business concept. Stationery items include letterhead, envelopes, and post cards. Since they are usually the first business promotion and/or communication items created for a new business, their look should be one that is easily carried over to other printed materials so that all of your materials have a "family" look. This includes your business card, which you will have occasion to include in mailings as well as hand out to prospects and colleagues.

CLIENT INFORMATION MATERIALS

Almost any photography business can benefit from having a presentation-quality folder of client-information materials. The purpose of such materials is to provide prospective clients with more in-depth information than could be communicated in a promotional brochure. Usually the folder is presented at the conclusion of a wedding photography consultation or a portrait planning session. When deciding on a design for your studio stationery, choose a design theme that can be carried through to these materials so they will reinforce the "design family" image of your business.

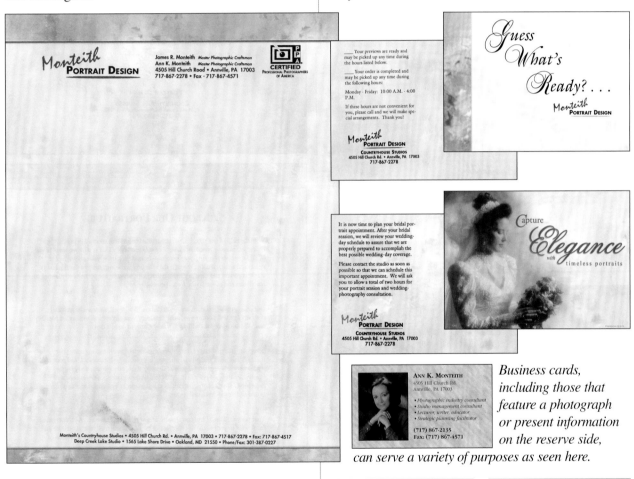

Business cards, including those that feature a photograph or present information on the reserve side, can serve a variety of purposes as seen here.

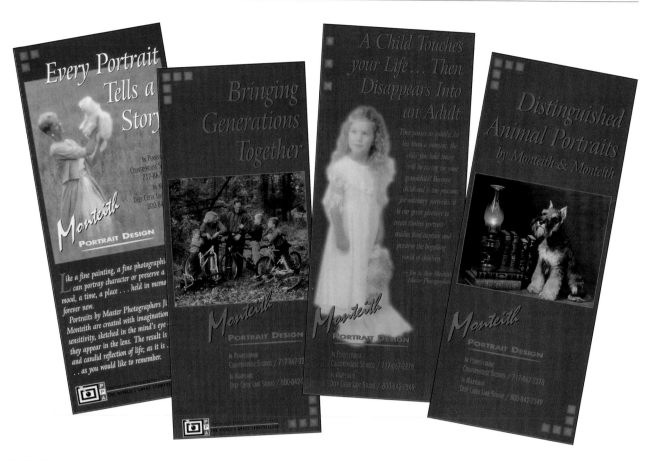

The purpose of these custom-printed brochures is to present the studio's various product lines in a manner that creates a positive image in the mind of prospective clients. The copy stresses the benefits of the studio's portraiture, rather than advertising "specials." This type of image building helps to make all other forms of promotion more effective by creating a desire for the studio's products.

source: Marathon Press
(800-228-0629)

IMAGE-PROMOTION PUBLICATIONS

Almost any business or profession can benefit from having a "capability" publication to provide clients with information about the goods and/or services offered by the organization. Such a publication—either in the form of a brochure or post card—is designed to promote "awareness" of the business itself and "comprehension" about what it does. Awareness and comprehension, as you will learn in the next chapter, are the first two steps in what sales experts call "The 5 Steps to Making a Sale."

When creating an image-promotion publication, remember that it is not the only form of promotion you are likely to do. An image piece should be designed to create a desire for your work among the clientele you are seeking. Its function is to help prospective clients to become interested in your business. Through other promotional advertising, you can build on this awareness and comprehension and further motivate prospects toward "conviction" and "trial," the next two steps in "The 5 Steps to Making a Sale." You will learn more about this process in the next chapter.

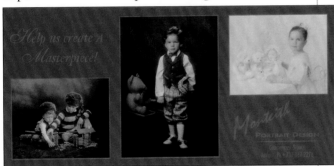

Even if your studio is located in a mall or prominent downtown venue that includes a store window for display, you cannot assume that all prospective clients will come in contact with that display.

So image-promotion brochures and cards, when they include color reproductions of your photography, will bring your "store window" to prospective customers through mailings and as handouts at bridal fairs and other displays of your work throughout the community.

Less expensive image-building publication options are shown above. The three post cards from left are "preset" products that allow photographers to combine their images, copy, and choices of backgrounds and typestyles to create a custom look, using established formats that help to reduce printing costs. The card at right is an even more cost-effective image-promotion approach. This "preproduced" post card contains typical portrait studio stock images. Such an option is appropriate for photographers newly in business or when a promotional card is needed for a special advertising use in which time is a factor.

source: Marathon Press (800-228-0629)

NATIONAL CONSUMER AWARENESS

Professional Photographers of America (PPA) makes available to its members consumer awareness programs that include a referral service for participating members. This valuable service helps to promote businesses directly to the consumer, as well as promote professionalism through association with this international organization.

The Art of Storytelling by Master Photographer James R. Monteith
-ONE OF THE WORLD'S GREAT STORYTELLERS-

The Story Behind The Portrait

"When Brandi arrived for her senior portraits, she was carrying a pile of clothing with "Alley Cat" on top. Only three weeks earlier, Brandi and her boyfriend had discovered the kitten lying beside a creek. He weighed only a few ounces and was nearly dead. They nursed him day and night, and now he's thriving. He loved being the center of attention for Brandi's favorite pose!"

-Jim Monteith, M. Photo., Cr.

 CERTIFIED

Monteith PORTRAIT DESIGN
COUNTRYHOUSE STUDIOS
4505 Hill Church Rd. • Annville, PA 17003
717-867-2278

Hours by appointment
Member - Professional Photographers of America
-The World's Great Storytellers-

The Art of Storytelling by Master Photographer James R. Monteith
-ONE OF THE WORLD'S GREAT STORYTELLERS-

The Story Behind The Portrait

"The first time I photographed the Ford kids, it was quite an event. Buffy (the dog) was great, but Jordan, the youngest child, was crying in every exposure except this one. When the Ford's came for their new portrait. I was really impressed with how the kid's had changed– both in looks and maturity. P.S. Buffy is still the boss!"

-Jim Monteith, M. Photo., Cr.

 CERTIFIED

Monteith PORTRAIT DESIGN
COUNTRYHOUSE STUDIOS
4505 Hill Church Rd. • Annville, PA 17003
717-867-2278

Hours by appointment
Member - Professional Photographers of America
-The World's Great Storytellers-

"Most photographers take pictures... I prefer to tell stories."

-Ann K. Monteith, Master Photographer

Your Family History Is Too Precious To Trust To Chance!

That's why our photographers are "PPA Certified."

Monteith PORTRAIT DESIGN
COUNTRYHOUSE STUDIOS
4505 Hill Church Rd. • Annville, PA 17003
717-867-2278
CERTIFIED

Your Wedding Pictures are Too Precious To Trust To Chance!

That's why our photographers are "PPA Certified."

Monteith PORTRAIT DESIGN
COUNTRYHOUSE STUDIOS
4505 Hill Church Rd. • Annville, PA 17003
717-867-2278
CERTIFIED

The direct-mail cards and their back copy, shown above, were created to support the consumer-awareness theme "The World's Great Storytellers," which can be used by all members of Professional Photographers of America (PPA). PPA's Certification logo was included in each and was central to the theme developed for the newspaper ads shown at left.

PUBLIC RELATIONS OPPORTUNITIES

Most well-managed businesses enhance their image through organized public relations efforts. These programs help to improve client recognition and create a demand for products and services. Public relations programs generally cost little and return excellent dividends, provided you are willing to invest the time necessary to achieve results.

NEWS RELEASES AND FEATURES — One of the most direct public relations efforts is to release news and feature stories to local media. An obvious topic is awards you have won in state, local, or national photography competitions. Others include news of personnel changes, new services offered, seminars you are either presenting or attending, and any remodeling or expansion of your firm's physical facilities. Whenever possible, use photographs to illustrate your stories.

Monteith's Countryhouse Studios
4505 Hill Church Rd.
Annville, PA 17003
717-867-2278

**Area Professionals Help Lebanon County Humane Society —
Sponsoring Free Health Check-Ups and Free Pet Portraits**

For Immediate Release December 9, 1997

On December 18 and 19 the Lebanon County Humane Society, recently in the news because of its financial problems, will benefit from a fund-raising partnership between Dr. Calvin Clements, director of the Palmyra Animal Clinic, and Jim and Ann Monteith, directors of Countyhouse Studios.

On those two days the Monteiths will photograph any pet brought to the studio, after which Dr. Clements or one of his associates will give the pet a routine medical checkup in return for a minimum donation of $15 to the Humane Society. The $15 donation will qualify the pet owner for a 5x7-size portrait. Portraits in larger sizes will be available for larger donations. All funds collected will go to the Human Society.

The portrait sessions and medical checkups will take place at Countryhouse Studios, 4505 Hill Church Road, Annville (intersection of Hill Church Road and Thompson Ave.), on Thursday and Friday (December 18 and 19), between the hours of noon and 8:00 P.M.

John Braun, president of the financially beleaguered humane society, is very pleased with this type of fund raising. "The days of getting enough funds through bake sales to support the society are gone", he said. "With a budget in hundreds of thousands of dollars today, and debts to match, we desperately need community help to keep from closing our doors"

-more-

A letterhead for news releases can be easily designed using desktop publishing tools. This professional approach will help to catch the eye of an editor at your local newspaper.

Feature stories on unusual aspects of your business or specific types of photography that the public might not be aware of should be illustrated with appropriate photographs. Some possible feature story topics include the value to women of glamour-makeover photography, the many options for family portraiture, executive portraits on location, portraits as wall decor, photographic restorations, and how to prepare your child for a photography session.

Your chances for having news releases and feature stories accepted by the media depend on a number of factors, including the editorial requirements of the paper, the professionalism with which you prepare the material, and your skill in dealing with newspaper personnel. In large metropolitan papers, your chances for placing news releases are slim. So if you are located in a major city but service a suburban market, your best chance is to seek out suburban dailies, weeklies, or "shopper" editions. If your area is serviced by a newspaper that relies even partially on local news, you most likely can place professionally prepared news releases and features. If you or a hired public relations professional can write a feature story that has broad appeal and plenty of human interest, a metropolitan paper might be interested. If you have difficulty getting your releases printed, try to make personal contact with a reporter or editor. Ask what the paper's editorial requirements are and who in the paper's hierarchy is most likely to be interested in the type of material you can provide.

Another way to establish a working relationship with local newspaper personnel is to do them a favor or two. If you plan to attend a local public event that you know the paper will be covering, you can volunteer to take whatever pictures the paper might require. They get the film for processing, and you get a photo credit.

SERVICE-CLUB PROGRAMS — An excellent way to promote your business is to present programs on photography to service groups and clubs. You can present slides of your work set to music or create informational programs on subjects such as glamour photography, to show to women's groups, or how to make the most of your

executive image, to show to business or service clubs. When addressing a group, bring several large, framed portraits to place on display. A well-dressed and neatly groomed photographer who perfects public speaking techniques will elevate his or her professional image quickly.

To make contact with civic groups that might wish to host a program, get a list of civic and social organizations from your local Chamber of Commerce. Then mail a letter that explains the program or programs you are willing to present.

SPECIAL EVENTS — For a new business owner who wants to create an awareness of her business, or for the established photographer who wants to call attention to a certain aspect of his business, a special event, such as an open house or a reception, can be beneficial. An open house is appropriate for a grand opening as well as for special weeks devoted to a single photographic subject, such as senior portraiture or wedding photography. If you create a series of executive portraits or groups of portraits for a special occasion, it is appropriate to host a reception to commemorate the "hanging" of the collection. Invite the subjects of the portraits, employees of the organization, and any members of the general public and news media who would be interested in viewing the portraits. If appropriate, plan brief remarks about how and why the portraits were created of each subject. The public relations value of focusing attention on your work under these circumstances is extremely high.

PARTICIPATION IN COMMUNITY ACTIVITIES

Participation in community activities by you and/or members of your staff can do much to create community recognition of your business and to elevate your business image. Through such participation, you are supporting activities and agencies that enhance the community from which you draw clients, and it is a fact that people like to associate with others who give back to the community. Your participation also makes you better known to other business people and community members who are likely to need photography.

You can support your community by joining business organizations such as the local Chamber of Commerce and national or local service clubs. Another avenue of community service is to provide photographic coverage for local agencies that must raise funds, such as the United Way, community hospital, or community symphony. Doing so in return for a credit line will help to provide your studio with widespread name recognition. In the next chapter you will learn more about the value of creating "partnerships" with local organizations.

Enhancing Perceived Value

Experience shows that people with discretionary income will buy things they value, even if it requires some sacrifice on their part. To enhance the public's perceived value of products and services, the photographer must make certain that his or her product itself, as well as the manner in which it is presented, stresses or implies a high level of value. This is accomplished in several ways that include building an identifiable style, creating a nurturing business climate, and providing exceptional customer service.

BUILDING AN IDENTIFIABLE STYLE

The public values what is unique, so a photographer whose work possess a clearly identifiable style— one that stands out in comparison to others—always benefits in terms of image.

The style can be one that is narrow in scope, such as a classic, low-key approach, or contemporary and high-key; or it can be very broad in scope, showing versatility and willingness to try a variety of styles and ideas, but always accomplishing the task with expression, feeling, and technical excellence. The notion of style can be a rather illusive concept, but when it is present, the product presents a sharply defined personality that underscore its value.

The images on the facing page demonstrate the visual power that an identifiable style brings to the business of image building. Dennis Craft, who takes advantage of the quaint Victorian locales found in his hometown, creates images of children that are instantly recognizable as his unique style. Likewise, Monica Cubberly-Early's charming portraits of babies stand out for their artistry and style.

The Environmental Style of Dennis Craft
Marshall, Michigan

The Gentle Style of Monica Cubberly-Early
Westerville, Ohio

The Contemporary Style of Larry Peters
Dublin, Ohio

The Timeless Style of Tim & Beverly Walden
Lexington, Kentucky

CREATING A NURTURING BUSINESS CLIMATE

A nurturing business climate is essential if a business is to attract and retain clients over time. The various elements that combine to create this environment have one thing in common: they serve to achieve both a first impression and a lasting recollection of the business. Each of the elements listed below must work in concert with the others to facilitate a positive image.

YOURSELF — If a business is to be successful, it needs to look successful. As the business owner, you need to look and act successful as well. Your physical appearance, your attire, your enthusiasm and personality, and your ethics and professionalism all interact to project an image for your business. After assessing these personal traits, you must resolve to correct any that are found lacking. Improving your personal public relations is as necessary as improving your posing and lighting.

YOUR BUSINESS ETHICS AND INTEGRITY — Successful business owners usually subscribe to a personal code of ethics and integrity. Business integrity means that you stand behind your product and service. If the product quality and service you deliver are what they should be, then you have nothing to lose by offering a money-back guarantee, which always works to your marketing advantage. Integrity also means that you do everything possible to keep to your appointment schedule and that you deliver work when promised. Good business ethics also will keep you from criticizing competitors to your clients or prospects.

YOUR PERSONNEL — Your personnel represent you, therefore they must adhere to the same high standards you set for yourself.

At left are more examples of the image impact that a recognizable portrait style can achieve. Through his dynamic contemporary style, Larry Peters has become a national trend-setter in the business of photographing high school seniors. When Tim and Beverly Walden decided to narrow the focus of their business to the "timeless" look they favored over other styles of photography, they learned that clients could more readily distinguish what separated their work from that of competitors.

The impression that a job applicant makes when he or she arrives for a job interview is a measure of the impression that will be made on clients. Search for employees whose personalities project warmth, enthusiasm, and empathy. Be prepared to spend training time with all new employees so their client-handling skills can be fully developed.

FACILITIES — In terms of image enhancement, the design and decor of your facilities must be appropriate for the clientele you wish to serve. Whether your business facilities are modest or lavish, they must be neat, attractive, and entirely professional looking. Nothing can spoil the appearance of a business faster than clutter and overcrowding. Both your facilities and public displays should be cleaned thoroughly at least every other week and all public rooms should be straightened daily.

MERCHANDISING AND PRESENTATION — Effective merchandising is both an art and a science. You can prove this fact to yourself by visiting a mall that includes outlets of national-level retailers. Notice how products are arranged and lighted, and look at the different colors used by stores that cater to distinctly different clientele. These are only a few of the tools that merchandisers use to make their products appealing to the public; and these principles of display and design also can be used to add appeal and value to your photography.

EXCEPTIONAL CUSTOMER SERVICE

As the economy develops more service industries to make up for the nationwide decline in manufacturing, service is becoming the new standard by which clients measure business performance. As prices rise, the customer has every right to expect service of a high level. When business owners overlook this fact, they are likely to suffer because, to a very significant degree, customer service has become an important foundation upon which the image of a business rests.

Outstanding customer service requires a high level of managerial commitment. Serving clients well must be more than an occasional thing—

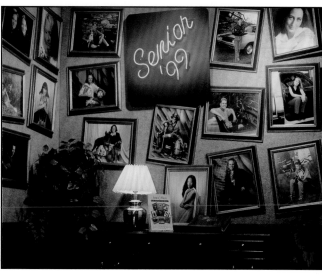

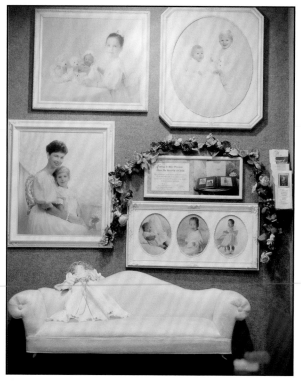

How products are presented or "merchandised" in the studio represents the single most important factor for adding value to products. The top two examples, from Sirlin Studios, Sacramento, California, show how portraits, when placed properly in conjunction with attractive furniture, have the effect of dominating the space. This adds value to the portraits in the mind of clients simply because they occupy a "position of value." When clients are allowed to "connect" with images in this manner, their mind-set changes from one of price to one of desire.

The two bottom images from the author's Countryhouse Studios location in Annville, Pennsylvania, show how a collection of images, combined with furniture and prop items, command the eye to linger over two different specialty areas: photography of children and photography of high school seniors.

something you and your staff invoke only when things are going well and only in the presence of "good" clients. Topnotch customer service must be an every-day attitude—one that is characterized by sincere friendliness. It requires a staff that is interested in going the "extra mile" for clients—a staff that has the ability to handle and satisfy the occasional disgruntled client, and one that lets clients know the business appreciates their patronage. Only if you and your employees are people-centered and service-oriented, will you be successful in achieving an exceptional level of customer service.

CLIENT-CENTERED CUSTOMER SERVICE

It pays to go out of your way to serve clients in ways they don't expect. Offering refreshments during planning and sales sessions is a touch of hospitality that elevates your image. Simple gestures, such as hanging up a client's coat, holding the door for clients, and helping them to the car with their packages, are expressions of your concern. In short, good manners are good business.

Neatness of your facility also helps to articulate values to clients. A tidy facility tells clients you care about their comfort; it communicates to them that you are likely to approach their photography with the same care. Also important to your clients are studio policies, because it is through them that you communicate your ethics. Policies, therefore, should be designed with service in mind and not bureaucratic rigidity.

When clients call for information on the status of an order, it is important to have this information at your fingertips. This requires a user-friendly computer system and software that retrieves information at the touch of a keystroke. It is important to recognize that a computer is more than a device to record business information; it is also an important customer-service tool.

Another way to keep clients happy is to underpromise and over-deliver. For example: If your normal portrait delivery date is four weeks, then tell the client it will take five weeks. That way, the client will be surprised and delighted to have the work finished one week early. And if there should be a problem with the order, you can still meet the time schedule you quoted to the client.

HANDLING DISGRUNTLED CLIENTS

Even the best-managed studio cannot please all of its clients all of the time. But before you conclude that a client with a complaint is really a disgruntled client, try to find out what the complaint is really about. Often the seeming complaint is only a question. Just as some clients are overly aggressive in the way they express themselves, some oversensitive studio owners and their staff members react to every question as if it were a confrontation to be answered by a challenge. If you approach the problem with a smile on you face, in a cordial manner that indicates confidence, you can probably answer the client's question to her satisfaction.

When you conclude that the client is simply an unpleasant person who cannot be satisfied under any circumstances, the best thing to do is to stand behind your product and service in the form of a money-back guarantee.

In those cases in which you or a staff member are guilty of an oversight, missed a deadline, or had some other type of misunderstanding with a client, here's what to do:
• Acknowledge the mistake. Don't become defensive or make excuses. Let the client know that you recognize the error.
• Apologize and empathize. "I'm so sorry for causing this problem, Mrs. Smith. I know how disappointed I would be if this had happened to me."
• Determine what course to take to solve the problem. "Here's what I'd like to do, Mrs. Smith. I'll have my lab print the missing 5 x 7 portrait on a rush basis, and I'll send it to you via overnight mail. You should have it within a week. Is that satisfactory?"
• Fix the mistake—Immediately! Nothing has higher priority than keeping your word to a client whom you have wronged.
• Provide "compensation." Even if your mistake is nothing more than forgetting to order a 5 x 7, do something nice for the client. The little bit of time and expense needed to order a unit of wallets when you place the 5 x 7 order will pay high dividends when you present the wallets to the client as a way of saying you are sorry for the error. The degree of compensation provided

_____ Does your business have a yearly public relations plan?

_____ Does your firm regularly send press releases to publicize awards you win in print competitions?

_____ Do you publicize personnel appointments?

_____ Do you publicize new products?

_____ Do you publicize other staff accomplishments?

_____ Do you prepare feature stories about unusual aspects of your business or about special products such as glamour photography, animal photography, or executives on location?

_____ Do you communicate with your clients through a newsletter?

_____ Do you keep a thorough client data base so that you can send greetings and appropriate promotions on the occasion of birthdays, anniversaries, etc.?

_____ Do you send holiday greetings to your clients?

_____ Do you follow up your sales with a thank-you letter?

_____ Do you provide "little extras" to your clients in the form of appropriate refreshments or a token with the finished order, such as a photo key chain, photo note card or wallet calendar?

YOUR BUSINESS FACILITIES

_____ Is your place of business plainly marked by professional signage?

_____ Is your building properly maintained, freshly painted, and are your grounds and shrubs neatly kept?

_____ Is your interior space well planned so that everything can be kept neatly in place?

_____ Are your public rooms neat at all times?

_____ Are your facilities cleaned regularly?

_____ Are your furnishings coordinated to create a decor that is appropriate for the level of clientele you seek?

_____ Have you visited the facilities of your competition and determined that the overall impression of your business remains competitive?

_____ Is your camera room a pleasing environment for both you and your clients?

_____ Is your work area an efficient and pleasing environment for both you and your employees?

_____ Is your waiting area comfortable for clients?

_____ Is your merchandise arranged to facilitate sales through "suggestive selling" and without conveying a hard-sell approach?

_____ Are related merchandise items grouped together so that clients can easily find what they are looking for?

_____ Are your wall groupings and other displays properly lighted?

_____ Do you play pleasing background music to enhance the environment of your studio?

_____ If you have a window display, is it changed frequently, and is it appropriate for the season?

_____ Is your window display properly lighted and easily seen from the street?

_____ Are your office hours neatly posted on your building exterior, and are they noted prominently in all promotional material?

_____ Are any off-premises displays neatly maintained, stocked with brochures, and up-to-date for the season?

YOUR PROMOTIONAL MATERIALS

_____ Does your studio logo readily convey the image of how you want your studio to be perceived?

_____ Are your promotional materials well-designed and eye-catching?

_____ Are your promotional materials designed to attract the attention of your ideal customer?

Marketing The Business

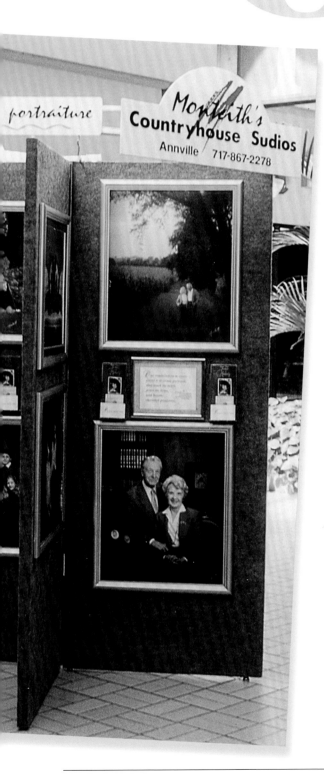

*D*etermining the needs and wants of prospective and existing clients is critical to the growth of a photographic business. This task is a function of marketing. Marketing greatly enhances any photographer's ability to attract and retain clients. It is not selling per se, although sales and marketing greatly affect one another: Marketing creates the conditions under which more sales can be made.

The Purpose of Marketing

A marketing plan is essential for the success of a business because it can:
• Open the door to new clients
• Foster customer loyalty to the business
• Increase word-of-mouth referrals
• Make sales easier
• Add value to products and services

The "Marketing Mix"

Marketing is an on-going process that involves identifying prospective customers; determining their needs and wants; creating a demand for the products the business sells to fulfill those needs and wants; and then selling and servicing the client so that customer satisfaction and referrals are ensured. The components that affect the success of a marketing plan are often referred to as the "marketing mix," or the "4 P's" of marketing. They are:
• Product
• Promotion
• Place
• Price

A "product" is defined as a combination of benefits, physical features, and services designed to satisfy the needs of a market. In general, consumers react to **benefits**, not **features**. **Features** are facts about the product. **Benefits** are what the product does for

the customer. It is benefits that the customer buys—not features. For example:

Product: **A professional portrait**
Features: A beautiful background, outstanding lighting techniques
Benefits: The subject looks good!

Product: **A wedding album**
Features: Contains 30 8 x 10 portraits
Benefits: Captures the beauty of the most romantic day of your life and preserves that priceless memory forever

Product: **Senior portrait session**
Features: 20 poses, including 3 clothing changes
Benefits: Express your fantasy in the latest "fashion poses" that will make you look and feel like a fashion model

Effective marketing, then, stresses the benefits of a product and not its features.

"Promotion" informs prospective customers that the company has the right product, available in the right place, at the right time, and at the right price. The message to be communicated is intended to inform potential clients just how your products and services meet their needs and wants and, in the process, perform the critical function of creating a desire on their part to patronize your business.

As part of the marketing mix, "place" ensures that business activities associated with offering the products and services take place at the right location, while the "price" component affects the company's ability to generate sales and create profits.

As you can see, the central elements of the marketing mix—product, promotion, place, and price—are intertwined to the extent that a change in one affects or necessitates changes in the others.

Establishing the Competitive Advantage of Your Product

The first step toward creating a demand for your photography is to establish what is called a "Unique Selling Proposition" (USP). It is through your USP that you stand out against competitors. One reason why clients give you sales is because you offer them something they can't get elsewhere. A dynamic USP clearly defines your advantage over competitors. It's the "I've got what my competitor can't offer" approach. Your USP can be based on any one, or a combination of, the following attributes:

• What your studio does
• Why you are unique
• Why you should get the sales
• Your advantages
• What you do well
• Your quality
• Dedication and commitment
• Distinctive style
• Why you should be trusted
• How you demand excellence
• The pride you take in your work
• What you honor
• Competitive prices
• Special bonuses, premiums, or gifts
• Wider selection of options
• Shorter delivery time than your competitor
• Specializing in a type or style of portraiture
• Guarantee
• Location
• Best value
• Experience
• You're the best—and can prove it
• If you're the leader—tell them

Once you have established your USP, let the world know about it. Your USP will bring your studio to mind when someone thinks about photography.

Example of a dynamic USP:

Children and their families are our business. We love children—especially babies—so much so that we have equipped our studio with a nursery and play area. Our entire staff holds degrees in early childhood education. Now you know why we are able to make such adorable portraits of our tiny subjects. And even with our low package prices, we guarantee your choice of backgrounds, sitting options, and complete satisfaction with your portraits!

Developing Marketing Strategies

As a professional photographer, you will employ an assortment of marketing concepts and tools to create effective marketing strategies. Your marketing plan is likely to include strategies developed for all or some of these marketing concepts:

• Advertising and Promotion
• Displays and Exhibitions
• Direct-Mail Marketing
• Sales Letters
• Person-to-Person Promotion
• Telemarketing
• Marketing Via the Internet
• Partnership Marketing
• Client Education
• Customer Service
• Relationship Marketing

Advertising and Promotion

Even though you may have done an exceptional job of creating a positive image for your business, consumers must be continually motivated and persuaded to buy. You accomplish this motivation and persuasion through advertising and promotion. Although different, they are closely related and often confused.

Advertising delivers your message to target groups in order to inform, influence, and motivate them to buy. It attracts new clients, helps to retain existing clients, and encourages them to increase their activity with you. The ultimate purpose of advertising is to make sales. Advertising is, in effect, salesmanship in print or via electronics. It is the basis upon which you realize the ability to attract the clients from whom you will gain the sales that result in profit. Without advertising, businesses die.

Promotion should be thought of in terms of "campaigns"—the combination of many activities, such as the creation of a special offer, advertising, displays—all of which combine to encourage and motivate prospective clients to buy.

For advertising and promotion to be successful they must be continuous. A one-time promotion or ad is not a fair test of whether a marketing strategy is working. Sporadic and reactive efforts in these areas are a waste of time and money. Advertising and promotion must be frequent and consistent if you are to maintain a solid relationship with your existing clients and let new prospects learn about your business.

As you plan your promotional campaigns, remember the three cardinal rules of advertising:

• Advertising takes planning.
• Advertising takes time and patience.
• Advertising takes repetition.

YOUR ADVERTISING/PROMOTION BUDGET

Promotional funding is always a dilemma: The newer the company, the greater the need to spend money on promotion; yet there is less income to spend. That is why it is so difficult to come up with an ideal percentage-of-income guideline for promotional activities. Experience shows, however, that most successful studios spend between five and ten percent of their anticipated gross sales on promotional activities. Other generalities about promotional funding are:

• Studios in less favorable locations require more promotion.
• New and expanding businesses spend more on promotion.
• Strong competition raises the size of the promotional budget required.
• Studios stressing price appeal usually promote more heavily.
• Special events require more intense promotional activities.

CREATING COMPELLING ADS

For prospects to buy what you have to sell, they must first know what you have to offer and what's in it for them. The story you tell through advertising must be compelling. Most compelling ads have the following attributes in common:

• An attention-grabbing headline
• Interesting copy
• The reader becomes involved

GUIDELINES FOR CREATING EFFECTIVE ADS

1—Use an attention-grabbing headline—one that promises the reader a grand and appealing benefit and indicates who should read your message: engaged couples, seniors, children, business people.

2—Tell your story in terms of benefits and advantages.

3—Find a need and show how to fill it—so that readers perceive photography as enhancing their lives.

4—Be articulate and precise, telling your reader exactly what's in it for them.

5—Include a "call for action" so that the reader feels the need to act and knows what to do next and by what expiration date the action must occur.

6—Add a satisfaction guarantee that reduces any risk on the part of the reader.

7—Make your offer believable by explaining why you are making the offer that others cannot make.

8—Test your ads (particularly the headline and special offer) on a sample audience in order to eliminate what doesn't work before you launch a costly campaign.

9—Offer added value—such as "Buy one get one free," or add more service—better service, faster service. (If you want to leave your competitors in your dust, simply go and ask the marketplace what they want.)

10—Use your photography in every ad, and include testimonials whenever possible.

THE POWER OF TESTIMONIALS

If you have a great product and have developed a good reputation, you have an almost inexhaustible source of great copy—practically free—written by your own customers. They will come up with selling phrases straight from the heart that no copywriter, no matter how brilliant, would ever think of. They will write with a depth of conviction that the best copywriters will find hard to equal.

5 STEPS TO MAKING A SALE

Always remember that the ultimate goal of advertising is to make sales, keeping in mind that your ability to create a sale results from taking the client through a step-by-step process that is profoundly affected by the success of your advertising. Here is how the process works:

| V. Loyalty |
| IV. Trial |
| III. Conviction |
| II. Comprehension |
| I. Awareness |

STEP ONE—AWARENESS

Clients will deal with you only if they know you exist—if they become "aware" of you. In order to achieve awareness, then, your advertising must spell out distinctly who you are and what you do. Conveying your location also can support awareness. Example: Sunshine Studio of Photography. Downtown—Next to the Courthouse.

STEP TWO—COMPREHENSION

Prospective clients also must "comprehend" what you do. If you advertise that you make the finest dye transfer prints in the world, you probably won't sell many portraits, because the public doesn't comprehend what a dye transfer print is.

So your promotional pieces must convey to the reader a message that is easy to comprehend, such as: "This is a photography studio that does romantic wedding photography, located in my area."

STEP THREE—CONVICTION

This is a critical step in persuading prospects to use your services. They will experience conviction only if they believe that what you offer might have some use for them. "Conviction" is built in many ways, including word-of-mouth-advertising. Clients who receive top-notch products and services from your studio will tell their friends about you. This facilitates conviction better than any advertisement can. So don't overlook the power of testimonials as a way to achieve conviction through your advertising.

STEP FOUR—TRIAL

Once conviction is established, your next task is to induce prospective clients to try your services. "Trial" is greatly facilitated by an appealing offer, coupled with a "risk reducer" (such as a satisfaction guarantee) and a "payment facilitator" (such as a payment plan or acceptance of credit cards).

STEP FIVE—LOYALTY

The trial stage gives the photographer the opportunity to do what he or she does best. When all goes well—when the product, the pricing, and the service meet or exceed the needs of the client— then it is possible for the client to develop loyalty: the ultimate achievement in the client-studio relationship. Loyal clients not only come back again and again, they tell others about your business.

Any form of advertising and promotion can go only so far in moving prospective clients through the steps toward sales: advertising merely opens the door to the trial stage. An unfriendly voice on the telephone can slam that door shut. An unpleasant portrait session or product that doesn't live up to the expectations that were set up through the advertising approach can adversely affect the sales outcome. These negative "trial" experiences cannot be blamed on the advertising.

CREATING PROMOTIONAL ACTIVITIES

Among the types of promotions that are workable for portrait/wedding photography are the following:

• Premiums — such as "This month only: a free portrait key chain with each order."
• Bonuses — such as "Buy one 8 x 10, get a second 8 x 10 at half price.
• Price off — such as "$50 off each wall portrait.
• Limited-time-only specials — such as a live baby bunny promotion.
• Games/contests — such as "Beautiful Baby Contest," "Prize-Winning Pet Contest," "Most Creative Senior Portrait Contest."
• Coupons — Include coupons that promote other product lines.
• A "Frequent Buyers' Club" — one that provides purchasing incentives for repeat clients.

STEPS IN THE PROMOTIONAL PROCESS

The failure of a studio promotion almost always can be traced to lack of planning—planning in the area of promotion concept, promotion timing, media selection, and identification of all of the steps necessary to implement the promotion. The following steps are essential to promotional planning and execution:

• Develop a promotional theme.
• Establish financial objectives.
• Prepare advertising copy.
• Decide what advertising media will be used.
• Develop a schedule of steps to activate the media.
• Implement the steps to launch the promotion.
• Measure the promotion's results.

Following is an overview of advertising and promotional media that are especially effective in marketing portrait/wedding photography:

Portraiture Displays and Exhibitions

There is no better tool for promoting photography than public displays and exhibitions. In the case of a visual medium, there simply is no substitute for showing what you do. Displaying is important whether your studio is in your home, in an out-of-the-way area, or in a high-traffic location, because displaying allows you to reach different market populations.

DISPLAY OPPORTUNITIES

Display location possibilities are almost limitless. To succeed in placing displays in appropriate locations, you must first identify the person who has the authority to approve the proposal that you present with skill and professionalism. Always see the proprietor or chief executive of the business or organization. If the business is part of a chain, ask to see the regional manager, as the local store manager usually does not have the authority to O.K. your request. Places that are likely to accept photographic portraiture for display include:

• Restaurants
• Retail Stores (Make sure you target display prints to the types of clients who patronize these establishments. Show senior portraits in teenage clothing stores; children's work in children's stores; bridal candids and formals in bridal shops and florist shops; sportsmen in sporting goods stores; pet portraits in pet shops; and so forth.)
• Beauty Salons (Display portraits of the various beauty operators. Salons are great places to facilitate word-of-mouth advertising.)
• Banks
• Libraries
• Hospitals
• Art Shows
• Professional offices (such as pediatricians, children's dentists, obstetricians, etc.)

TEMPORARY MALL EXHIBITIONS

Display policies differ from mall to mall, but many will allow displays for a week at a time, sometimes as part of a special theme week. Some require a fee and some do not. Increasingly, mall managers and store owners are recognizing that photography is a powerful drawing card to bring people to malls areas, and many are eager to have attractive displays on their premises. Moving into malls outside of your local area will help to expand your effective market base.

PERMANENT MALL DISPLAYS

The most effective means of bringing your work to the attention of a broad audience is to establish permanent displays in high-traffic malls visited by shoppers who fit your studio's ideal customer profile. Arranging for mall displays typically is not easy, and always it is a test of your professionalism.

First, determine some locations within the mall where a display of your work could be placed. Next, decide what type of display apparatus would be appropriate, then have an artist's rendering of the apparatus created. Finally, determine how much you are prepared to spend on monthly rental for the space. Most mall rentals are based on the amount of traffic that the location generates: the more traffic in the mall, the higher the rental. In some cases you can negotiate an arrangement in which you provide photographic services for the mall in exchange for display space. If you take this route, make sure that your photographic obligations are clearly defined so that you do not find yourself in the position of being "on call" at the whim of the mall management.

When you are ready to make your presentation, do not contact the mall manager, but rather ask to see a representative of the mall's leasing company. Often the leasing company is located out of town, but a representative will make frequent on-site visits.

APPROPRIATE DISPLAY APPARATUS

In order to organize effective, professional-looking displays, well-constructed display apparatus is essential. Some malls provide panels on which to hang prints at temporary exhibits, but at others you must provide your own display apparatus, tables, and easels. Folding aluminum tables of 8 feet to 10 feet lengths can be obtained in variety or office supply stores (you'll need an attractive table cover). Display panels are available from professional display houses, but depending on the type of display, it is sometimes necessary to construct your own equipment. Don't forget that you'll need printed signs, attractive frames, and appropriate handout materials.

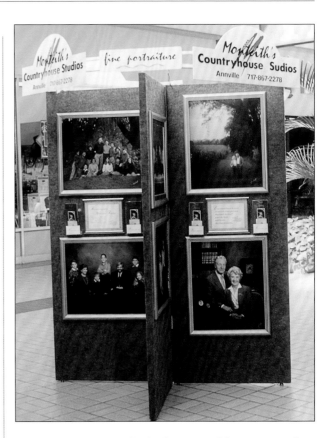

Mall displays provide the best possible exposure for portrait/wedding photography. Experience shows that displays create the kind of awareness and comprehension that make all other forms of advertising more effective.

Two factors to keep in mind when displaying your portraits are: First, you must have a signed model release on file before displaying images; and second, when displaying a child's portrait, never identify the portrait with the name of the subject as a matter of protection for the child against criminals who have been known to prey on children whose photographs they have seen.

Direct-Mail Marketing

Direct-mail marketing, the powerfully dynamic promotional tool that has turned entrepreneurs into retail giants, is the form of advertising used most by professional photographers.

DIRECT-MAIL MARKETING PRODUCES IMMEDIATE, MEASURABLE RESULTS

Direct-mail marketing is one of the most effective and cost-efficient communications techniques available to help small-business owners compete and flourish in the big-business world. It gives you the ability to promote specific products and services to specific categories of customers, any time you want, and in a way that's almost as effective as a personal sales call. It delivers your sales message directly to individual customers or prospects in a way that prompts them to take some form of immediate action.

Like other forms of advertising, successful direct-mail marketing requires repetition—that is, multiple mail drops of the promotion, particularly when the mailing is going to "cold" prospects (prospects who might not know anything about the business). The effectiveness of direct mail also can be enhanced when used in combination with other media such as displays and newspaper ads.

WORKING WITH MAILING LISTS

The right mailing list is crucial to the success of a direct-mail campaign. Mailing lists are available through both internal and external sources.

INTERNAL SOURCES — Direct-mail experts agree that a mailing to one's own client list is generally more effective than an identical mailing to a purchased list, because your best customer is the one you already have. Generally, it requires fewer mailings to current clients than it does to prospects.

EXTERNAL SOURCES — Mailing lists are available from hundreds of "list brokers" who compile lists of businesses or consumers by various classifications. You can choose your desired market target based on demographic characteristics such as ZIP Code, gender, age, household income level, home ownership, families with children, families with new babies, and occupation.

Be alert to other opportunities for building a data base of prospects to use with direct-mail promotions. Those who call to inquire about your portraiture but don't book an appointments should be added to your prospect file if they wish to be informed about future specials. Retail businesses or other professionals whose client bases are similar to yours are possible resources for additions to your prospects file. You also can compile lists from telephone directories (choosing area business owners or professionals, for example), industrial or municipal directories, local associations, your Chamber of Commerce, and other public sources. By keeping in mind the source of your lists and the demographic characteristics of names on the list, you can tailor an approach to prospects for individualized promotions.

SAVING MONEY THROUGH BULK MAILING

Before planning a direct-mail campaign, visit your local post office and ask for information on bulk-mail rules and regulations. You can achieve significant savings on postage if you comply with bulk-mailing regulations. The rules change constantly, so it is wise to discuss your mailing with the local postmaster.

SAVING MONEY ON PRINTED MATERIALS

Photographers can achieve savings on printed materials by understanding the advantages of and differences among three types of printing: **preproduced** printed materials, **preset** printed materials, and **custom** printed materials.

PREPRODUCED PRODUCTS — Preproduced printed materials are cards and brochures that feature high-quality stock images typical of work produced by portrait/wedding studios. These materials can be personalized with your choice of back copy and your studio information.

The grouping of promotional post cards shown at right above are "preproduced" publications that contain typical stock images. Available in most photographic specialities and for specific types of promotions, they are well-designed, cost-effective and quick to launch.

source: Marathon Press (800-228-0629)

The card below is a "preset" publication that blends the photographer's images, copy, and background elements with a predesigned format.
source: Marathon Press (800-228-0629)

PRESET PRODUCTS — When there is a promotional need that a preproduced product will not satisfy, then the next most economical printing option is a "preset" product. Preset formats allow you to "drop in" your photography and copy to an established format, thus saving the time and cost of creating a custom layout. This arrangement allows you to create custom-looking materials in small quantities at an affordable cost.

CUSTOM PRINTING —Although it is more costly, custom printing allows a business complete freedom in designing printed advertising materials. It is sometimes possible to save money on custom printing by having a complete press sheet printed that can include multiple cards and/or brochures.

Sales Letters

As part of your direct-mail program, sales letters can be an important tool to use when prospecting for new clients as well as for building goodwill and loyalty with your existing clients. What's more, sales letters provide a unique vehicle for telling the whole story of your products and services.

ADVANTAGES OF SALES LETTERS

A sales letter makes an impression on any reader who has an interest in its subject matter. A sales letter is a way of communicating on a one-to-one basis, without having to devote the time to making personal calls. It is an excellent way to become acquainted with potential clients or maintain on-going contact with your existing clients.

A sales letter is the next best thing to a sales call. In fact, it functions as a "no-pressure sales call."

The custom-designed cards shown at left were printed at the same time, as a single press sheet, in order to save money over the usual cost for custom printing one card at a time. Because each card uses similar design elements, it heightens the recognition factor of potential clients who receive the cards over time.

source: Marathon Press (800-228-0629)

The reader can choose to read the letter, respond to it, or throw it away. There is no intimidation—real or imagined—and no irritation with feeling "put on the spot" by having to respond immediately.

CHARACTERISTICS OF EFFECTIVE SALES LETTERS

Sales letters work best when they are:
• Personalized. A personalized letter makes the reader feel special and important.
• Attention-getting
• Interesting to read
• Targeted to a specific market, such as seniors, families, or weddings. Only send your letters to those who are the most likely to buy.

Your letter must immediately attract the reader's attention—and then keep it to the very end. Ideally, you want the reader to take the action called for in

Sales letters are the next best thing to a sales call, allowing you to tell your whole story. They are even more effective when they include images.

source: Marathon Press (800-228-0629)

Studio Telemarketing

Telemarketing has become an increasingly important part of many photographers' sales efforts, as it is one of the most powerful revenue-generating tools available to a photography business.

Making the most of telephone opportunities becomes even more important as studios grow and diversify their marketing strategies. This only makes sense: Spreading the word through advertising, public relations, and other promotional efforts inevitably results in increased inquiries. The trick is to capitalize on each call, incoming or outgoing, and make it pay off with positive, profitable results.

Telemarketing includes both inbound and outbound calls. Inbound refers to all calls that come into the studio, while outbound refers to the process of contacting customers or prospects by phone. The object of both forms of telemarketing is sales. To succeed, customers must believe that the business is genuinely concerned about their needs and wants. The role of the receptionist/phone operator is key here, and that is why hiring a people-oriented person to staff this position is so important.

Well-managed studios usually provide their employees with a variety of telephone "scripts" to guide them in answering typical inquiries. While not designed to be "read" to prospective clients, scripts are an excellent resource to assure that all important talking points are covered. Good scripts are designed to facilitate the next most important step in the promotion-to-sales process, such as establishing an appointment for a portrait planning session or a wedding photography consultation.

Telephone sales training is available in most areas. Such training, combined with intelligently crafted scripts, can help to bolster the promotion and sales efforts of any photography business.

Marketing Via the Internet

Unquestionably the fastest growing marketing technology today is the Internet. Each month, hundreds of thousands of households log on to the Internet for the first time. Many photographers are exploiting this exciting medium by creating their own web sites for the purpose of advertising and selling.

In addition to showing "photo galleries," a web site can provide browsers with information about a firm's products and services. Stock photographers use the Internet for direct selling of images, and wedding photographers use it to allow out-of-town guests to purchase wedding photographs.

There are several options for creating a web site. You can build it yourself through the use of "editor" software. Numerous web site design companies can do both the design and maintenance of your web site, or you can purchase preproduced web pages. Many organizations that offer these pages also can host and maintain your site.

As appealing as a web site is as a means of direct communication with potential clients, you must remember that very few people are likely to visit your web site unless you have a means of letting prospects know that you have a web site to visit. Therefore, all of your advertising media should invite prospective clients to visit your web site.

Other Marketing Media

Newspapers, radio, and television all enjoy the advantage of broad public recognition. Often you can gain customers through lesser-mentioned media such as billboards or advertising give-away items imprinted with your studio identity. Each has its specific advantages and challenges. Before using any medium, familiarize yourself with its characteristics and how it can influence the public on behalf of your studio product lines. Keep in mind that "one size fits all" does not apply to advertising media: Some product lines are advertised to best advantage through one medium, whereas other product lines can be advertised more effectively through entirely different media. The table on page 71 is designed to help you discern advantages and disadvantages of the various types of media that should be considered when planning advertising and promotional campaigns for a photography business.

Preproduced web site pages, featuring "galleries" of the photographer's images, as well as information about the business, are an inexpensive way to gain promotional exposure on the Internet.
source: Marathon Press (800-228-0629)

Partnership Marketing

Sometimes referred to as cross marketing, cooperative marketing, or joint-venture marketing, "partnership marketing" is a proven method of promoting sales in cooperation with non-competing businesses. Partnership marketing involves reciprocal endorsements by merchants or professionals who share a similar client profile or joint promotional ventures in which the partners split the costs incurred, such as printing and mailing. This form of marketing is used successfully by large and small businesses in a variety of fields, and it is especially well-suited for portrait/wedding studios. The "third-party endorsement" feature of the partnership is what provides you with a credibility that is hard to match. The perception is, "If you are associated with the best . . . then you must be the best."

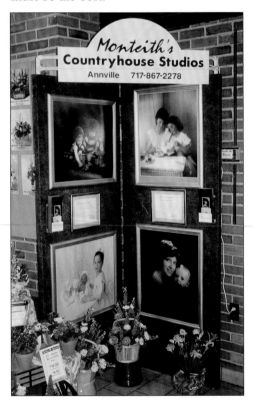

A marketing partnership with a floral shop provides the studio with a place to display portraits in exchange for photographs of original floral designs that the florist uses in his promotional efforts.

source: Marathon Press (800-228-0629)

Partnership marketing capitalizes on the goodwill built up by your partner associates. People generally don't like making decisions when they are uninformed, and an easy way out is to follow the recommendation of someone they respect. So put this tendency to work for your advantage by finding partners who can recommend you. Appropriate partners for wedding photographers include florists, tuxedo rental businesses, bridal shops, and jewelry stores. Portrait photographers might partner with retail stores, furniture stores, boutiques, clothing stores, and the like. Remember that photography is a commodity that has great appeal to most people, and many established business people would be pleased to recommend a photography business in return for photographs of their products in use or for personal portraits of themselves or their families.

When establishing partnerships in your community, remember to look for opportunities to display photographs in your partners' locations; and whenever a partner is willing, make use of his or her client mailing list for promotional mailings.

Relationship Marketing

One of the keys to long-term business success is "relationship marketing"—an approach to clients that supposes a long-term association with repeat clients. It is a view of clients that appreciates them not only for the sale you make today, but more importantly, for the sales you will make to them in the future. Because the concept of relationship marketing is based on providing clients with an outstanding product, delivered in a context of superior customer service, what it achieves for a business is a long-term competitive advantage. As a result, there is no more important marketing strategy for studios than establishing these long-term relationships.

The concept of relationship marketing sprang from businesses that recognize they extract the majority of their profits from repeat customers "over time." For such businesses, the profitability of the first sale is of very little concern. What they strive to do during that introductory transaction is to sew the seeds of a relationship that will transform the first-time customer into a "customer for life."

Fall/Winter, 1998
What's New at MONTEITH'S?

National Children's Program Helps Parents Create Portrait Histories of Children and Families

We are pleased to announce that we have joined with a select group of studios throughout the U.S., Canada and abroad in a program designed to provide parents with a structured plan to ensure that their precious family photographs are preserved so they can be passed down from generation to generation.

Entitled "Once Upon A Lifetime," the program is sponsored by Professional Photographers of America. Over the years, many of our clients have told us they regretted not having more portraits made as their children and family changed and grew. It's not that they didn't place enough value on portraits to come to the studio more often, they simply led busy lives, and the years slipped by before they knew it.

Through the "Once Upon A Lifetime," program we can offer our clients a variety of structured plans that allow us to photograph children and families at regular intervals. The resulting photographs can be preserved in beautiful heirloom albums as well as displayed in the home as eye-catching wall decor.

Please call us to learn more about this exciting new program. We'll explain the many money-saving ways you can create portrait histories to enjoy today and treasure for a lifetime.

— Jim & Ann Monteith

Call Soon For Holiday Portraits!

Even though portraits are the perfect holiday gift, many people don't think about portraits until it's too late. Although Thanksgiving is the final deadline for placing holiday orders, it's not too soon to start planning you special gift portraits. And don't forget that Countryhouse Studios offers special hours for family portraits during the holiday season when families get together.

Countryhouse Studios Offers Affordable New Children's Portrait Plan

As a studio affiliated with the "Once Upon A Lifetime" children's portraiture program, Jim and Ann Monteith have created an affordable plan for parents who want to have their children photographed at regular intervals and choose to preserve these childhood milestones as a "portrait history."

For a brochure that explains the new program and a booklet that answers the important question "When Should My Child Be Photographed?" call during office hours, which are Monday thru Friday, 10:00 - 4:00.

Monteith
PORTRAIT DESIGN
COUNTRYHOUSE STUDIOS
4505 Hill Church Rd. • Annville, PA 17003
717-867-2278

Long-standing relationships with clients are built by offering outstanding products and exceptional customer service and by keeping in touch with clients. You can do so through such means as a studio newsletter, birthday cards to younger clients, and written communications that show your appreciation and interest.

source: Marathon Press (800-228-0629)

Monteith
PORTRAIT DESIGN

James R. Monteith *Master Photographic Craftsman*
Ann K. Monteith *Master Photographic Craftsman*
4505 Hill Church Road • Annville, PA 17003
717-867-2278 • Fax - 717-867-4571 • Monteith@AOL

April 2, 1998

Mr. & Mrs. Donald Jackson
16 Mill Creek Lane
Annville, PA 17003

Dear Don and Nancy,

Don't be surprised if your friends call to tell you that you're a celebrity, because a sample portrait from your sitting is now on display at the Lebanon Plaza Mall.

I am proud to display such a lovely portrait. It was a great pleasure making your portrait, and I thank you again for giving me the opportunity to work with you.

Yours truly,

James R. Monteith

Monteith's Countryhouse Studios • 4505 Hill Church Rd. • Annville, PA 17003 • 717-867-2278 • Fax: 717-867-4517
Deep Creek Lake Studio • 1565 Lake Shore Drive • Oakland, MD 21550 • Phone/Fax: 301-387-0227

Monteith
PORTRAIT DESIGN

James R. Monteith *Master Photographic Craftsman*
Ann K. Monteith *Master Photographic Craftsman*
4505 Hill Church Road • Annville, PA 17003
717-867-2278 • Fax - 717-867-4571 • Monteith@AOL

September 1, 1998

Mr. & Mrs. William Jorgenson
6 Crestview Circle
Palmyra, PA 17078

Dear Bill and Roxanne,

We are pleased and appreciative that you referred Bill & Mary Roberts to our studio. You and your portraits are the best testimonial to the quality of our work and customer service. Rest assured that we will do our best to please the Roberts family.

It is through referrals such as yours that our business continues to grow. As a token of our appreciation, we are enclosing a gift certificate for a complimentary sitting which can be used by you or any member of your family.

Thank you again for such an outstanding expression of confidence in our work.

Yours truly,

James R. Monteith

Monteith's Countryhouse Studios • 4505 Hill Church Rd. • Annville, PA 17003 • 717-867-2278 • Fax: 717-867-4517
Deep Creek Lake Studio • 1565 Lake Shore Drive • Oakland, MD 21550 • Phone/Fax: 301-387-0227

They stress the "lifetime value" of the customer as it translates into many transactions that yield income over a period of years.

In a photographic business, your goal for each new client is to have them return as often as possible. This requires special attention on your part during the "acquisition" process and during the ongoing "maintenance" process. In relationship marketing, the emphasis is on the individual client and communicating on a one-to-one basis. When you succeed at relationship marketing, your clients automatically think of your studio when they think about photography.

Another benefit of relationship marketing is that it cuts your marketing costs. You don't have to spend as much to keep your existing customer coming back as you do to attract new clients. When you build these types of relationships, your clients will become enthusiastic advocates of your business, because satisfied customers enjoy spreading the word to their friends and acquaintances. They become your champions—your own unpaid sales force—and they, themselves, are likely to try other products you offer.

DATA BASE MANAGEMENT

The innovation of computers and data bases is what has made it practical to practice relationship marketing. Computers that support data base software are your most efficient and effective marketing tool for building and maintaining long-term relationships with your clients, as well as for client prospecting. In fact, your data base is the engine that drives many of your marketing efforts.

Building the data base is simple. The only challenge is to know how you will use the information to increase your sales. Build your own list by storing only the information you are likely to use, and be sure to keep it updated. Here are some suggestions:
• Name
• Address
• Telephone
• Records of product lines purchased and amount of purchase
• Names of family members

• Birth dates of children
• Lifestyle information such as hobbies and pets
• Date of parents' anniversary.

This kind of information makes it possible to create a plan for effective marketing activities.

ASKING FOR REFERRALS

When an intimate relationship with a client is established and sustained, you have created a situation in which the client is most likely to tell others how great you are. Capitalize on this relationship by asking clients for referrals. Referrals help your studio to prosper. When you have a good relationship with a client, it's quite natural to ask for referrals, and most clients are comfortable with giving you names to contact. If you wish, devise a program to reward referrals, but recognize that most of your loyal clients are willing to provide them without any reward. For these loyal customers, a better idea is simply to give them an unexpected "treat" from time to time to show them how much you appreciate their business and their loyalty.

A FINAL WORD ABOUT RELATIONSHIP MARKETING

For relationship marketing to work for your business, all of your marketing strategies must be designed to attract and retain clients. This takes planning and commitment, but it is worth the effort. The reward is that you achieve what should be the objective of any business: long-term profitability in an environment that makes dealing with clients as much a pleasure as it is a business.

Additional in-depth information on marketing for portrait/wedding businesses is available in the sister publication to this volume, *The Professional Photographer's Marketing Handbook.* For information or to order contact Marathon Press at (800) 228-0629.

Pricing Photography

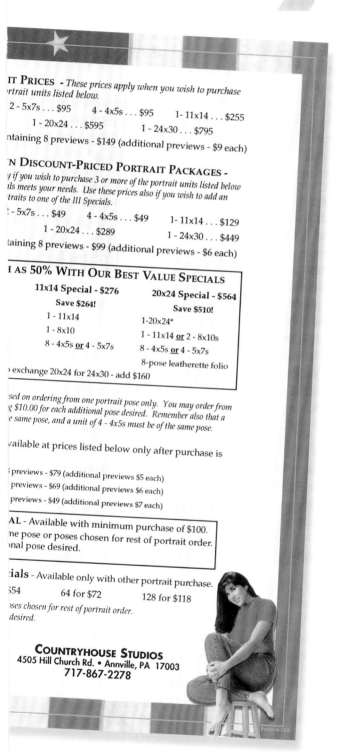

IT PRICES - *These prices apply when you wish to purchase* ...*rtrait units listed below.*

2 - 5x7s . . . $95 4 - 4x5s . . . $95 1 - 11x14 . . . $255

1 - 20x24 . . . $595 1 - 24x30 . . . $795

...ntaining 8 previews - $149 (additional previews - $9 each)

N DISCOUNT-PRICED PORTRAIT PACKAGES -
...y if you wish to purchase 3 or more of the portrait units listed below
...ls meets your needs. Use these prices also if you wish to add an
...traits to one of the III Specials.

2 - 5x7s . . . $49 4 - 4x5s . . . $49 1 - 11x14 . . . $129

1 - 20x24 . . . $289 1 - 24x30 . . . $449

...taining 8 previews - $99 (additional previews - $6 each)

I AS 50% WITH OUR BEST VALUE SPECIALS

11x14 Special - $276 **20x24 Special - $564**

Save $264! Save $510!

1 - 11x14 1-20x24*

1 - 8x10 1 - 11x14 **or** 2 - 8x10s

8 - 4x5s **or** 4 - 5x7s 8 - 4x5s **or** 4 - 5x7s

 8-pose leatherette folio

...o exchange 20x24 for 24x30 - add $160

...sed on ordering from one portrait pose only. You may order from
...g $10.00 for each additional pose desired. Remember also that a
...e same pose, and a unit of 4 - 4x5s must be of the same pose.

...vailable at prices listed below only after purchase is

... previews - $79 (additional previews $5 each)

... previews - $69 (additional previews $6 each)

... previews - $49 (additional previews $7 each)

...AL - Available with minimum purchase of $100.
...ne pose or poses chosen for rest of portrait order.
...nal pose desired.

...ials - Available only with other portrait purchase.

...54 64 for $72 128 for $118

...ses chosen for rest of portrait order.
...desired.

COUNTRYHOUSE STUDIOS
4505 Hill Church Rd. • Annville, PA 17003
717-867-2278

Of all the many services-for-hire, photography is one of the most difficult to price. It is a challenge to determine how much to charge for most types of portrait or candid photography because of the complex nature of the service being rendered. Most businesses provide a service, sell a product, or manufacture a product. Photographers, however, provide a service, sell a product, and most supervise the "manufacture" of the product. This makes the management aspect of a photography business infinitely more complicated than most businesses and adds complexity to the task of pricing. However, when you understand the relationship between what it costs to do business and how much to charge in order to be profitable, then pricing photography is greatly simplified.

In the previous chapter we noted that the price a business charges for its products is part of the "marketing mix." Price affects the marketing mix in the following ways:

Price is a communication device. It creates an image of the photographer's business in the eyes of the customer. The prices set must create the right type of image for each customer and each buying situation.

Price is an indicator of value to the customer. Consumers buy when they consider something to have value. This is often expressed in a simple equation: benefit divided by price equals value. In other words, every time a consumer is confronted with a buying decision, she subconsciously assigns a worth to the benefits perceived. At the same time, she assigns a value to those benefits. Subjectively and subconsciously, the consumer compares one to the other to reach a buying decision. If the benefits outweigh the price, she will buy. If the price outweighs the benefits, she will not buy. This equation notwithstanding, the consumer sometimes assumes that the higher-priced product represents better quality.

Price also works as a competitive technique. Smart marketers use price as an attention-getting device that

POSSIBLE COST OF SALES EXPENSES

Film (black and white and color)

Contract labor or time charge (based on hourly charge estimate for the type of photography being priced—usually wedding photography)

Lab Costs
- Processing film
- Printing proofs
- Making finished prints (Be sure to include chemical and paper costs for all items produced in a house lab in addition to the costs incurred through a commercial color lab.)
- Shipping charges (for proofs and finished pictures)

Retouching/Print Finishing
- Retouching
- Art work charges or supplies
- Print spray charges or supplies
- Mounting charges or supplies (If any of these services is done by an employee, a charge must be established per job when pricing.)

Accessories
- Frames
- Albums
- Proof folios/presentation mounts
- Photographic merchandise such as photo invitations
- Packaging materials

Why Cost of Sales is Important

The obvious reason why accurate accounting of Cost of Sales is so important is that you have to know what your costs are in order to charge enough to make a profit. Some novice photographers, because of their enthusiasm for making pictures, actually charge less for their finished work than they spend for the raw materials. This happens because it is easy to overlook charges such as retouching or shipping and handling. More than a few photographers have forgotten to list film as an expense!

Once you know how much it costs to make your product, how do you decide how much to charge?

You cannot answer this question until you know how much profit you intend to make or the total cost of your General Expenses. The first step toward this end in any photography business is to understand the relationship between Cost of Sales, General Expenses, and Profit. This relationship can be expressed in percentages, and it is presented for a typical photography studio as shown below:

	Total Sales	100%
—	Cost of Sales	40%
=	Gross Profit	60%
—	General Expenses	50%
=	Net Profit	10%

What this relationship means is that for every dollar (expressed as 100 percent) received from the customer, not more than 40 cents (expressed as 40 percent) of that dollar should be spent to make the product. By determining that the maximum allowable Cost of Sales is 40 percent of Total Sales, you establish a discipline that affects not only your pricing, but also the rest of your business structure. When you subtract the 40 percent Cost of Sales from your Total Sales, the result is a Gross Profit of 60 percent. Gross Profit is the amount remaining after your product is produced. If, as the figures above suggest, you are successful in limiting your General Expenses to 50 cents for every dollar received (expressed as 50 percent of Total Sales), then you will realize a Net Profit of 10 cents for every dollar received (expressed as 10 percent).

These ratios help to pinpoint troublesome areas of your business. Should you experience a drop in profits that is not related to a decline in sales, you can determine where the problem lies by looking at your Cost of Sales and General Expenses percentages. General Expenses will be discussed further in Chapter 9, so for the time being let's concentrate only on how the relationship between Sales and Cost of Sales affects pricing.

As already suggested, your Cost of Sales should not exceed 40 percent of your Total Sales. Remember, this means that for every dollar you take in, it shouldn't cost more than 40 cents to manufacture your product. This is a **maximum** guideline. Industry experience shows that when Cost of Sales rises above the 40 percent level, only a business with exceptionally low General

Expenses can survive. Studios with higher overhead, therefore, must operate at a lower Cost of Sales percentage. Most financially successful photographers, in fact, suggest that 30 percent is a more realistic Cost of Sales guideline.

As you become accustomed to working within a Cost of Sales guideline, you will learn, as the figures below show, that when you lower Cost of Sales to 35 percent (Figure B) from the original 40 percent relationship (Figure A), with all other factors being equal, Net Profit increases by 5 percent. If you lower your Cost of Sales to 30 percent of Total Sales, you can increase your General Expenses to 60 percent of Total Sales without changing the Net Profit of 10 percent (Figure C).

Figure A
40% Cost of Sales • 50% General Expenses

	Total Sales	100%
—	Cost of Sales	40%
=	Gross Profit	60%
—	General Expenses	50%
=	Net Profit	10%

Figure B
35% Cost of Sales • 50% General Expenses

	Total Sales	100%
—	Cost of Sales	35%
=	Gross Profit	65%
—	General Expenses	50%
=	Net Profit	15%

Figure C
30% Cost of Sales • 60% General Expenses

	Total Sales	100%
—	Cost of Sales	30%
=	Gross Profit	70%
—	General Expenses	60%
=	Net Profit	10%

Monitoring Cost of Sales

Monitoring your Cost of Sales percentage is one of the most important keys to business success, because it allows you to bring discipline to the manufacturing function of your business. If you begin to see a trend toward a higher Cost of Sales over a period of months, then you are alerted to the need to lower your manufacturing cost ratio. Otherwise, you are jeopardizing your "bottom line" or Net Profit.

There are only three methods of lowering your Cost of Sales ratio:
• Find less costly ways of producing the product.
• Use smaller amounts of goods (such as film) to produce the product.
• Raise the price of the product.

The Mechanics of Pricing

Setting prices, then, begins with the mechanical exercise of determining all of the goods and services that go into each product. The next step is to multiply those costs by a "mark-up" factor that assures your prices will achieve the Cost of Sales (COS) you require, given the amount of your General Expenses. The factor itself is determined by dividing the Cost of Sales percentage into 100. For example:

To arrive at the mark-up factor for a COS of 40%, divide 40 into 100.
The result is a COS factor of 2.5.

To arrive at the mark-up factor for a COS of 35%, divide 35 into 100.
The result is a COS factor of 2.9.

To arrive at the mark-up factor for a COS of 30%, divide 30 into 100.
The result is a COS factor of 3.3.

Thus, if production of an item takes $100 worth of materials, its price would be:

At a 40% Cost of Sales: Multiply $100 by 2.5.
The price would be $250.

At a 35% Cost of Sales: Multiply $100 by 2.9.
The price would be $290.

At a 30% Cost of Sales: Multiply $100 by 3.3.
The price would be $330.

In the example that follows, you can review the actual mechanics involved in pricing a wedding photography package for a hypothetical wedding studio:

Pricing for an "Economy Wedding Package" consisting of:
• 6 hours of coverage
• 1 bridal album containing 24 8 x 10 images
• 2 parent albums, each containing 20 4 x 5 images

In this exercise we will price each of the three elements listed above separately and then combine them to arrive at the cost of the "Economy Wedding Package." There is a practical reason for pricing each of the three elements separately. Doing so allows you to create other packages or products using one or more of the single elements already created, combined with additional elements. For example, you might wish to create another package that includes the same 6 hours of coverage with a bridal album that contains 50 images instead of 24. There is no need to re-price the 6 hours of coverage since you already have done so.

Following is a listing of the various costs for the three elements in the "Economy Wedding Package."

Costs for 6 Hours of Coverage

Processing and proofing of 10 rolls of color print film @ $6.50 per roll	$65.00
Proof shipping	$2.00
Proof book (@$50, but used 3 times)*	$16.50
Proof book shipping	$2.00
6 hours contract labor at $25 per hour	$150.00
10 rolls of color print film @ $3.50	$35.00
6-Hour Coverage Total	$270.50

* To arrive at a "per use" charge for the proof book, divide the total cost of the item by the number of uses you expect the item to give before it is worn out and discarded.

Costs for the Bridal Album

8 x 10 album cover	$50.00
8 x 10 album cover imprint	$5.00
Studio imprint	$2.00
12-8 x 10 album inserts @$3 each	$36.00
24-8 x 10 album mats @$1 each	$24.00
Album shipping	$5.00
24-8 x 10 deluxe color candid prints @ $4.10 per print	$98.40
Print order shipping charge	$2.00
24-Page 8 x 10 Bridal Album Total	$222.40

Costs for 20-Page 4 x 5 Parent Album

4 x 5 album cover	$40.00
4 x 5 album cover imprint	$3.00
Studio imprint	$2.00
10-4 x 5 album inserts @$2 each	$20.00
20-4 x 5 album mats $.50 each	$10.00
Album shipping	$5.00
20-4 x 5 deluxe color candid prints @ $1 per print	$20.00
Print order shipping charge	$2.00
20-Page 4 x 5 Parent Album Total	$102.00

To create the "Economy Wedding Package," add the following:

6-Hour Coverage	$270.50
24-Page 8 x 10 Bridal Album	$222.40
2-4 x 5 Parent Albums @ $102.00	$204.00
Economy Wedding Package Costs	$696.90

To calculate the price at a 30% Cost of Sales, simply multiply $696.60 by the COS mark-up factor of 3.3:

$696.60 x 3.3 = $2,323.00

What is important to learn from this sample exercise is how critical it is to go through the mechanics for each of your products—being certain to include each cost. The mathematical result will be the **minimum** guideline necessary to achieve a profitable sale. The exercise has shown that to achieve a profitable sale at the 30% Cost of Sales level, you must charge at least $2,323 for the "Economy Wedding Package." Generally, you will round off the total. You could decide on $2,350. If you believe that the price will be competitive at a higher level, then raise it accordingly.

As you might expect, keeping track of each of the many costs associated with creating a photographic product and calculating prices using the correct Cost of Sales mark-up factor can be tedious, and there is plenty of room for error. Using a computer to automate this task lessens both the monotony of the process and the opportunity for error. SuccessWare® is the only studio management package that includes pricing software as part of its fully integrated applications.

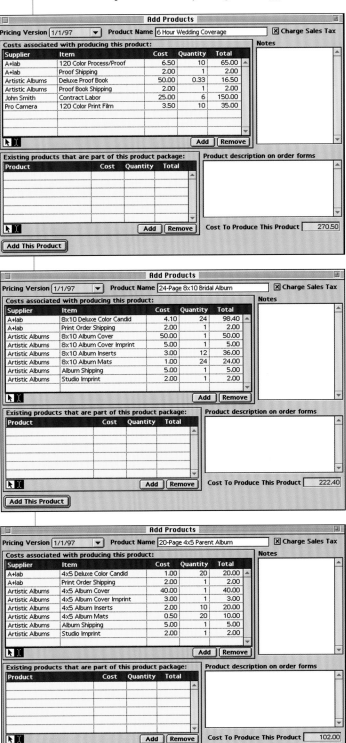

List Costs

Supplier	Item	Cost
A+lab	120 Color Process/Proof	6.50
A+lab	16x20 Artboard	14.00
A+lab	16x20 Canvas Mounting	35.00
A+lab	16x20 Color Candid	16.00
A+lab	16x20 Print Spray	2.00
A+lab	4x5 Deluxe Color Candid	1.00
A+lab	8x10 Deluxe Color Candid	4.10
A+lab	8x10 Unit	3.53
A+lab	Art 15 minutes	15.00
A+lab	Neg Retouch/Head	2.50
A+lab	Print Order Shipping	2.00
A+lab	Proof Shipping	2.00
A+lab	Wallets set of 8	3.50
Artistic Albums	4x5 Album Cover	40.00
Artistic Albums	4x5 Album Cover Imprint	3.00
Artistic Albums	4x5 Album Inserts	2.00
Artistic Albums	4x5 Album Mats	0.50
Artistic Albums	4x5 Folio	12.00
Artistic Albums	6 Pose Folio	8.00
Artistic Albums	8x10 Album Cover	50.00
Artistic Albums	8x10 Album Cover Imprint	5.00
Artistic Albums	8x10 Album Inserts	3.00
Artistic Albums	8x10 Album Mats	1.00

Pricing Version 1/1/97

Print Delete Change By %

Shown at right are the three components for the "Economy Wedding Package," created in a matter of minutes via computer automation, by simply clicking on the various cost components previously entered in the accompanying window shown above.

Source: Success Pricing application of SuccessWare®
(800 593-3767)

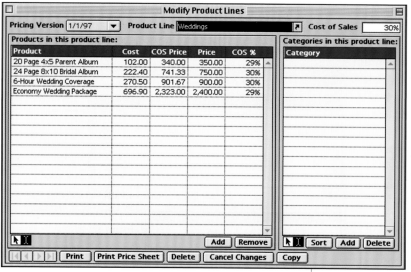

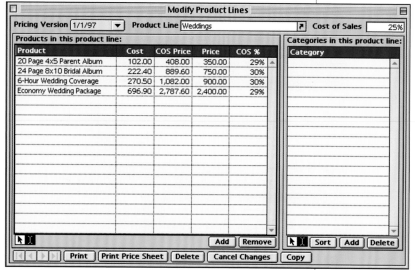

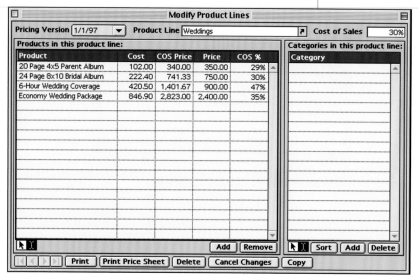

In the top screen shown at left, you will note that each of the three components of the "Economy Wedding Package" are listed in addition to the package itself. The figures in the "Cost of Sales Price" column were automatically calculated by the software at a 30 percent Cost of Sales factor, based on the total costs entered for each of the products. Note also that the figures in the "Price" column are entered by hand to reflect the price that actually will be charged to the client, with the resulting COS percentage posted in the right-hand column.

In the middle and bottom screens, you will see how automation in pricing allows you the freedom to see immediately the consequences of changing any of the components that affect pricing.

In the middle screen, the Cost of Sales percentage has been changed from 30 percent to 25 percent. Here you can see what this 5 percent difference makes in the prices that must be charged to maintain this COS level.

In the bottom screen, the Cost of Sales percentage remains at 30 percent, but the cost of contract labor has been raised from $25 per hour to $50 per hour. Although the change was made through the "Costs" screen, the new Cost of Sales price is automatically changed in the "6-Hour Wedding Coverage" and "Economy Wedding Package" components, as they are the two products affected by the price change. To keep both within a 30 percent Cost of Sales range, the price of each would have to be raised to reflect the hourly increase for contract labor.

Source: Success Pricing application of SuccessWare® (800-593-3767)

The Art and Science of Pricing

The mathematics of pricing cannot be denied: it is the **science** which assures that each transaction not only pays for the cost of making the product, but also makes a "contribution" to General Expenses and Profit. There is, however, also an **art** to pricing. Finding the right "price point," building profitable "packages," and creating effective price lists are functions that bring the art and the science together.

The Relationship Between Price and Volume

The mathematically accurate Cost of Sales price for a product (the price calculated by the Cost of Sales mark-up factor) is not always the price that will sell the most units or even create the highest sales. So when looking for the best "price point" for a product—particularly if your business concept involves sales to the mass market—you must consider what price will create the most profit for each product. This means the price point must be one that is both cost-oriented and market-oriented.

For example, let's consider a product that has a Cost of Sales of $5.00. Using a 40 percent Cost of Sales guideline, the mark-up factor would be 2.5, therefore the client cost would be $12.50. Suppose, however, that your experience leads you to believe you could double the number of buyers if your price was no higher than $10.00. Let's see what the effect on profit would be at the two different price levels:

Selling Price	$12.50	$10.00
Projected units of sales	500	1,000
Projected sales	$6,250.00	$10,000.00
Cost of Sales	$2,500.00	$5,000.00
Contribution to General Expenses and Profit	$3,750.00	$5,000.00

As you can see in this example, if you are likely to double the number of units by lowering the price to $10.00 per unit, the actual profit returned to the business is greater than if you sold fewer units at a higher price. If, however, the increase in units requires additional staffing, you very possibly

might wipe out any profit gains you have achieved in lowering the price. You would have to factor in the additional staff expense to see what the profit reality would be under these circumstances.

The price-volume relationship also is important in guiding the direction of the business. A good example of this is seen in the typical profile of wedding photographers who begin their careers by photographing weddings part time, while holding down a full-time job in another field. Such a photographer usually starts out charging only enough to cover expenses and put a few dollars in his or her pocket while gaining experience and getting work before the public. As the photography improves and the demand for it grows beyond what can be serviced, the photographer ultimately raises the price in order to regulate the demand.

Pricing Strategies

The most costly product (to the business) that a photographer sells is the "first-unit-sold." To understand this reality, consider how much it costs to produce a single 8 x 10 portrait in a typical portrait studio. To illustrate, we will assume that the studio uses two rolls of film to produce a total of 20 paper previews for the client to view in selecting the final 8 x 10 print. The costs involved are as follows:

Costs for 1 8 x 10 Portrait

Film	$4.00	2	$8.00
Proofs	$8.00	2	$16.00
Proof Folio	$12.00	0.33*	$3.96
Shipping	$2.00	1	$2.00
8 x 10 Print	$4.00	1	$4.00
Retouch/Finishing	$15.00	1	$15.00
Folder	$1.50	1	$1.50
Total Cost of Sale			$50.46

* Represents a "per use" charge for the proof folio—arrived at by dividing the total cost of the proof folio by the number of uses (3) you expect the item to give before it is worn out and discarded.

Using a 30 percent Cost of Sales guideline to price the product, you would multiply the total of $50.46 by a factor of 3.3, with the result being $166.52. This means that the photographer must recover $166.52 from the client—in order to be profitable— if only one 8 x 10 is sold. This recovery can come from the 8 x 10 alone, or from a combination of the 8 x 10 and a session fee (such as a $50 session fee plus $117.00 for the 8 x 10 portrait).

For many photographers, particularly those who are new to the business, this price level is likely to be too high to attract many clients. So what must the photographer do to be profitable? Let's look at two possible strategies: Creating "packages" that feature value to the consumer, and creating sales systems that assure profitable sales by way of selling larger prints and/or multiple-print orders.

PRICE-POINT PACKAGING

What this type of packaging recognizes is that the first-unit-sold is the unit that bears the largest expense because it includes the film, processing, and proofing in addition to the cost of the print and its presentation mount. Any subsequent units sold, however, must bear only the cost of the print and the presentation mount. So by combining additional units and/or accessories with the first unit, it is possible to create packages that represent both a good value to the consumer and an appropriate profit for the photographer.

For example: Let's assume that a studio wishes to create package pricing for children's portraiture and the desired Cost of Sales guideline is 30 percent.

We already know that a single 8 x 10 must be sold at a price of $166.52. But let's assume that the photographer fears he will be unable to sell 8 x 10s at that price level. Our job, then, is to create a collection of packages that will simultaneously discourage the client from buying just a single 8 x 10 and encourage her to purchase a more expensive package. For our example, we will create four packages, the first three of which contain the following:

Package 1: 1 8 x 10
Package 2: 1 8 x 10, 1 unit of 8 wallets
Package 3: 1 8 x 10, 1 unit of 8 wallets, 1 unit of 4-4 x 5s

PACKAGE 1 —

1 8x10 Portrait

PACKAGE 2 —

1 Unit of 8 Wallets 1 8x10 Portrait

PACKAGE 3 —

1 Unit of 4-4x5s 1 Unit of 8 Wallets 1 8x10 Portrait

Now let's set the prices for these three packages as follows:

Package 1: $149.00

Package 2: $179.00

Package 3: $249.00

Now let's examine the Cost of Sales percentage of the three packages when these prices are charged:

Package Number	Product Cost	Math Price	Client Price	Actual COS %
1	$50.46	$166.52	$149.00	34%
2	$53.96	$178.06	$179.00	30%
3	$68.96	$227.57	$249.00	28%

Notice how the product cost of Package 2 only increases by $3.96. That's because the only additional cost incurred is for the wallet unit. There is no print finishing or presentation mount required.

There is a larger cost differential when the unit of 4-4 x 5s is added in Package 3, because these portraits will require finishing as well as presentation mounts. From the client's point of view, the increase in price from Package 1 (which does not offer high value) to Package 3 (which now includes a total of 13 portraits) is likely to be perceived as of higher value.

Now let's take the concept of greater value to the client one step further and see what we can add to create Package 4, doing so at only a slight increase in cost to the photographer. Experience shows that parents assign high value to receiving all of the previews along with their finished portraits. Since the previews are already paid for, let's add them to the package and also include a 6-pose leatherette preview folio (a nice presentation for mom or dad's office), as well as a 4-pose mat that can hold four additional previews (a nice accent for the home). Here's what the new package will look like:

PACKAGE 4 —

1 Unit of 4-4x5s 1 Unit of 8 Wallets 1 8x10 Portrait

6-Pose Preview Folio 4-Pose Mat & Previews

10 Previews

You will probably agree that Package 4 is by far the most attractive because it contains so many appealing products. A skillful sales person will point out the benefits of owning the entire collection. In comparing the prices of the first three packages, pricing Package 4 at $379.00 would be a reasonable price point to still remain a good value. As seen in the table below, when priced at this level, Package 4 produces the most favorable gross profit margin of all the packages.

Package Number	Product Cost	Math Price	Client Price	Actual COS %
4	$93.96	$310.68	$379.00	25%

SALES SYSTEMS THAT ENCOURAGE SALES OF LARGER PRINTS

Another strategy that responds to the difficulty in recovering the cost of the first-unit-sold is to set up a sales system that encourages the sale of larger print sizes. As the size of the print increases, the client expects to pay more; yet the ratio of the increased cost to the photographer is not nearly as great as the ratio of the increased selling price to the consumer. This becomes evident in the following illustration based on costs incurred in various image sizes:

Image Size	Product Cost	Math Price	Client Price	Actual COS %
8x10	$ 50.46	$167.00	$ 95.00	53%
11x14	$ 65.41	$216.00	$255.00	26%
16x20	$ 83.95	$277.00	$420.00	20%
20x24	$111.45	$368.00	$595.00	19%
24x30	$140.65	$464.00	$795.00	18%

Assume that the photographer intends to stay within a Cost of Sales of 30 percent. What the table above shows is that each print size after the 8 x 10 level achieves the goal. The 8 x 10, however, does not. So why would the photographer choose to sell the 8x10 at this price? Her strategy would be a good one if she is using the $95 price as a "loss leader" to acquire new clients, toward the end of "selling up" the client to a larger size portrait. Can she be assured of the larger sale? As you will learn in the next chapter, selling portraits by projection nearly always results in selling wall-size portraits.

PRICE LISTS THAT ENCOURAGE MULTIPLE-PRINT ORDERS

An "incentive" price list, such as the one shown below, can be used effectively to assure profitable sales in a manner that demonstrates value to the client. Section I lists the studio's "custom" prices, available to clients who choose a non-promotional session. Section II lists a second level of pricing that is available only for promotional sessions or specialized photography, such as senior portraiture, as is the case with this price list. In order to take advantage of the lesser price structure in Section II, the client must purchase a minimum of three portrait units. Otherwise, the client must purchase

at the "custom" rate displayed in Section I. By requiring the purchase of three units—even at a lesser price—the studio has surmounted the problem posed by the high cost to the business of the first-unit-sold. The client receives a better value, and the business derives the profit necessary to justify selling at the lower price to the client.

The packages reflected in Section III are created from elements priced at the same level as Section II. The purpose of the packages is two-fold: They provide a subtle encouragement toward a wall portrait purchase, and they respond to those clients who simply prefer to select a package by offering only those packages that result in high profit.

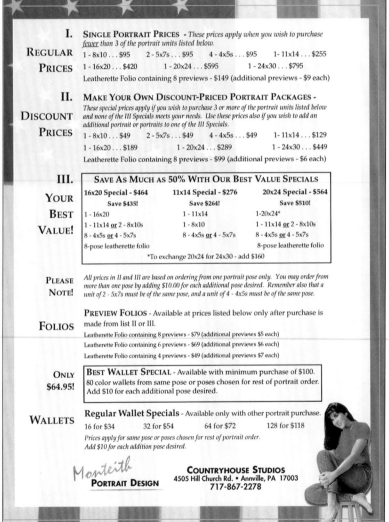

I. REGULAR PRICES

SINGLE PORTRAIT PRICES - *These prices apply when you wish to purchase fewer than 3 of the portrait units listed below.*

1 - 8x10 . . . $95 2 - 5x7s . . . $95 4 - 4x5s . . . $95 1 - 11x14 . . . $255

1 - 16x20 . . . $420 1 - 20x24 . . . $595 1 - 24x30 . . . $795

Leatherette Folio containing 8 previews - $149 (additional previews - $9 each)

II. DISCOUNT PRICES

MAKE YOUR OWN DISCOUNT-PRICED PORTRAIT PACKAGES -

These special prices apply if you wish to purchase 3 or more of the portrait units listed below and none of the III Specials meets your needs. Use these prices also if you wish to add an additional portrait or portraits to one of the III Specials.

1 - 8x10 . . . $49 2 - 5x7s . . . $49 4 - 4x5s . . . $49 1 - 11x14 . . . $129

1 - 16x20 . . . $189 1 - 20x24 . . . $289 1 - 24x30 . . . $449

Leatherette Folio containing 8 previews - $99 (additional previews - $6 each)

III. YOUR BEST VALUE!

SAVE AS MUCH AS 50% WITH OUR BEST VALUE SPECIALS		
16x20 Special - $464	**11x14 Special - $276**	**20x24 Special - $564**
Save $435!	Save $264!	Save $510!
1 - 16x20	1 - 11x14	1-20x24*
1 - 11x14 **or** 2 - 8x10s	1 - 8x10	1 - 11x14 **or** 2 - 8x10s
8 - 4x5s **or** 4 - 5x7s	8 - 4x5s **or** 4 - 5x7s	8 - 4x5s **or** 4 - 5x7s
8-pose leatherette folio		8-pose leatherette folio
	*To exchange 20x24 for 24x30 - add $160	

PLEASE NOTE!

All prices in II and III are based on ordering from one portrait pose only. You may order from more than one pose by adding $10.00 for each additional pose desired. Remember also that a unit of 2 - 5x7s must be of the same pose, and a unit of 4 - 4x5s must be of the same pose.

FOLIOS

PREVIEW FOLIOS - Available at prices listed below only after purchase is made from list II or III.

Leatherette Folio containing 8 previews - $79 (additional previews $5 each)

Leatherette Folio containing 6 previews - $69 (additional previews $6 each)

Leatherette Folio containing 4 previews - $49 (additional previews $7 each)

ONLY $64.95!

BEST WALLET SPECIAL - Available with minimum purchase of $100. 80 color wallets from same pose or poses chosen for rest of portrait order. Add $10 for each additional pose desired.

WALLETS

Regular Wallet Specials - Available only with other portrait purchase.

16 for $34 32 for $54 64 for $72 128 for $118

Prices apply for same pose or poses chosen for rest of portrait order. Add $10 for each addition pose desired.

Monteith PORTRAIT DESIGN

COUNTRYHOUSE STUDIOS
4505 Hill Church Rd. • Annville, PA 17003
717-867-2278

The incentive price lists shown here and on the facing page are presented to illustrate the structure of such a price list only and not to suggest price levels appropriate for any business other than Countryhouse Studios. Prices must be set according to the Cost of Sales, General Expenses, and Net Profit of each specific business.

The three price lists shown here were computer-generated and laser-printed in-house on color letterheads appropriate for the subject matter being priced. They illustrate the point that attractive price schedules need not and should not be expensive, so that adjusting prices does not become an expensive proposition—particularly when the business is new. Typically, a new business owner will adjust prices frequently as he or she experiments with pricing levels and price structures.

Price list letterheads source: Marathon Press
(800-228-0629)

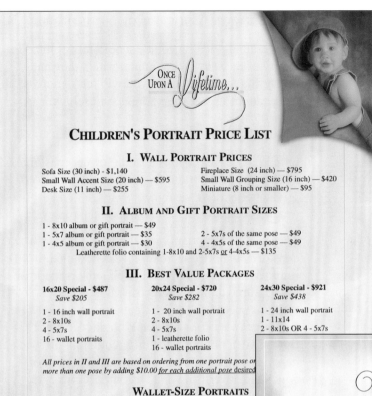

ONCE UPON A *Lifetime...*

CHILDREN'S PORTRAIT PRICE LIST

I. WALL PORTRAIT PRICES

Sofa Size (30 inch) - $1,140
Small Wall Accent Size (20 inch) — $595
Desk Size (11 inch) — $255

Fireplace Size (24 inch) — $795
Small Wall Grouping Size (16 inch) — $420
Miniature (8 inch or smaller) — $95

II. ALBUM AND GIFT PORTRAIT SIZES

1 - 8x10 album or gift portrait — $49
1 - 5x7 album or gift portrait — $35
1 - 4x5 album or gift portrait — $30
 Leatherette folio containing 1-8x10 and 2-5x7s *or* 4-4x5s — $135

2 - 5x7s of the same pose — $49
4 - 4x5s of the same pose — $49

III. BEST VALUE PACKAGES

16x20 Special - $487
Save $205

1 - 16 inch wall portrait
2 - 8x10s
4 - 5x7s
16 - wallet portraits

20x24 Special - $720
Save $282

1 - 20 inch wall portrait
2 - 8x10s
4 - 5x7s
1 - leatherette folio
16 - wallet portraits

24x30 Special - $921
Save $438

1 - 24 inch wall portrait
1 - 11x14
2 - 8x10s OR 4 - 5x7s

All prices in II and III are based on ordering from one portrait pose or more than one pose by adding $10.00 *for each additional pose desired*

WALLET-SIZE PORTRAITS

16 for 34 32 for $54

Monteith
PORTRAIT DESIGN
COUNTRYHOUSE STUDIOS
4505 Hill Church Rd. • Annville, PA 17003
717-867-2278

Wedding Photography

I. WEDDING PHOTOGRAPHY COVERAGE

8 hours of coverage—classical and photojournalism—unlimited venues — $2,500
6 hours of coverage—classical and photojournalism—up to three venues — $2,000
4 hours of classical coverage—church and reception — $1,500
Wedding Media Direction—including coordination and supervision of studio portraits,
candid wedding photography, videography, and production of wedding program
$5,000
(photographer/videographer fees available by quotation)

II. ALBUM AND GIFT-SIZE IMAGES

1 - 8x10 album or gift portrait — $49
1 - 5x7 album or gift portrait — $35
1 - 4x5 album or gift portrait — $30
Leatherette folio containing 1-8x10 and 2-5x7s *or* 4-4x5s — $135
(Leather-bound wedding albums available by quotation)

III. WALL PORTRAIT PRICES

Sofa Size (30 inch) — $1,140
Small Wall Accent Size (20 inch) — $595
Desk Size (11 inch) — $255

Fireplace Size (24 inch) — $795
Small Wall Grouping Size (16 inch) — $420
Miniature (8 inch or smaller) — $95

IV. WALLET-SIZE PORTRAITS

16 for $34 32 for $54 64 for $72

V. PORTRAIT CARDS AND ENVELOPES

Portrait note cards that accommodate a wallet-size portrait image. Available with
or without interior message imprint. Wallet-size portraits sold separately.

16 for $18 32 for $24 64 for $40

Monteith
PORTRAIT DESIGN
COUNTRYHOUSE STUDIOS
4505 Hill Church Rd. • Annville, PA 17003
717-867-2278

Another advantage to an "incentive" price list is that once the pricing levels are established, only slight modifications need to be made in order to adapt the same basic structure to price a variety of specialized product lines. This is evident when you compare the children's price list, shown above, and the wedding price list, shown at right, to the senior price list, shown at left.

Pricing—A Review

In terms of managerial decisions, few have as much impact on a business as product pricing, and few present as much complexity. To assure that you get off to a good start with this vital function, let's review a step-by-step process that will help you to price your products accurately.

STEP ONE — DETERMINE COST OF SALES

Decide what you believe would be a profitable Cost of Sales level based on your known or anticipated General Expenses. Keep in mind the industry guideline that suggests 40 percent as a maximum Cost of Sales mark-up for a studio that has low General Expenses and 30 percent as a maximum Cost of Sales mark-up for a studio with high General Expenses. If you are uncertain about where your General Expenses fall in terms of being high or low, consider hiring an industry consultant to review your expenses. Remember also that if you plan to move from a low-overhead to a high-overhead situation, or if you plan to give yourself a significant raise in salary, then it is wise to adopt the lower Cost of Sales guideline before you make the move in order to have sufficient revenue to pay the higher overhead and/or salary.

STEP TWO — DO THE MATH!

Determine the costs of each product you offer and multiply these costs by the relevant Cost of Sales "mark-up" factor. This tedious process can be simplified if you use pricing software.

STEP THREE — FINALIZE YOUR PRICES

Review the mathematical Cost of Sales prices you have computed and adust prices to fit your marketing strategy. Adjust them upward if you believe the price can be justified according to the market you are targeting. Adjust a price downward only if you wish to have a "loss leader" to use for marketing purposes—one that can be "sold up" through a proven sales system such as an incentive price schedule or transparency-proof projection.

DESIGN YOUR PRICE SCHEDULES

Well-crafted price schedules should reflect the reality of the sales system upon which they are based. In the next chapter, you will learn more about the relationship between pricing and selling.

A Final Word About Pricing

Of all business decisions a studio owner must make, none is more important than pricing. Over-priced products can drive customers away, yet under-priced products can drive a business into bankruptcy.

There is one important factor to keep in mind when considering a price increase that is designed to improve profits, as opposed to one that is made just to keep up with increased costs. It is that as a studio is successful in differentiating its product from that of its competition, it obtains greater flexibility in pricing. That differentiation, of course, depends on many factors, the most important of which are advertising and customer service. As advertising promotes studio recognition, it increases the potential client base and it also influences the overall level and stability of sales. As clients are rewarded with quality products, delivered within the context of outstanding customer service, positive word-of-mouth advertising about the business grows. These factors, in turn, support higher pricing and greater profits.

The Process Of Selling

*If you have read all the chapters in this book so far, you should now understand the importance of market targeting, product development, promotional planning, and product pricing. In accomplishing these critical tasks, you have set the stage for prospects to contact your business. When this happens, it is up to you and your employees to transform that prospect into a client. Whether the prospect contacts you in person by visiting the studio or through a telephone inquiry, he or she is literally at your "front door." To keep that front door from slamming shut, you must have strategies in place to satisfy the needs and wants of the client. Keep in mind that you are in business to **sell** your photography, not just to produce it.*

The Step-by-Step Process of Building Good Sales

Good sales don't just happen. They are the product of a well-defined plan that includes these vital components:
- Technical ability — the capacity to produce images of consistent and recognizable quality
- A positive studio image
- Savvy merchandising
- Skillful person-to-person sales presentations—based on well-defined sales systems—that help the client assign a high degree of value to the product
- A positive camera-room experience
- Post-sales strategies

By incorporating each of these elements into a plan, you will succeed in building a solid foundation for your sales efforts. Let's begin by reviewing some of the elements listed above that have not been specifically addressed in other chapters.

TECHNICAL ABILITY

One frequently overlooked aspect of achieving technical consistency is that of acquiring a basic technical education in portraiture. The industry is full of

call to inquire how plans are progressing and/or provide reminders about any pre-wedding photography sessions such as the formal bridal portrait.

THE PORTRAIT CONSULTATION

In many portrait situations, learning about the photographic needs and tastes of your clients is critical to both artistic and sales success. When a prospective portrait client calls, explain the importance of a planning session at the studio; or, if you don't have a formal place of business, then offer to go to the client's home.

The planning session or consultation is vital for several reasons:
• It gives you a chance to determine exactly what type of portrait you will make for the client.
• You have an opportunity to demonstrate what type of clothing will best complement the type of portrait being discussed.
• The session is an invaluable means of improving the eventual portrait sale by increasing the client's involvement in designing the portrait.

Predetermining the type and style of portrait is important because when it comes time for the portrait session itself, you already know what you are going to do with the subject(s), so you can get right down to work. There is no awkward period of fumbling for an idea. The planning session meeting gives you a chance to observe the client's physical characteristics and mannerisms as well as to discover what style of portrait is most appealing to him or her.

STEP ONE: PREPARATION

For the client, the portrait planning session is really a period of education. Most portraiture buyers are not aware of what goes into making a quality portrait, because they do not buy fine portraiture that often. If you were to ask the average person how many styles of family portraits there are, she is likely to reply, "A family portrait is a family portrait." Yet there are dozens of different types and styles of family portraits. It is up to you to educate your client as to the broad-ranging possibilities available in today's portraiture market. So you must be prepared with samples or printed material that illustrate the various types and styles of photography you offer, as well as those that show the importance of carefully selecting clothing to complement the artistic intent of the portrait.

STEP TWO: GREETING/INTRODUCTION

When clients arrive for the planning session, help them to settle in with a few minutes of small talk such as, "Have your seen our work before?" If you wish, offer coffee, tea, or soft drinks. "Selling yourself" through conversation and hospitality is an important aspect of gaining your clients' confidence, and it sets the stage for a successful business transaction as you move step-by-step through the process of creating and selling the portrait.

STEP THREE: CLIENT INTERVIEW

The client interview allows you to learn characteristics of the client that will help to guide the direction of the planning session. Begin by asking simple questions such as, "Do you consider yourself to be a formal or an informal person?" "Do you enjoy being out-of-doors?" "How many children do you have? "What types of activities do you enjoy?

STEP FOUR: DETERMINING TYPE, STYLE, AND LOCATION OF THE PORTRAIT

You client(s) may know **what** they want photographed (the type of portrait), but they are unlikely to know **how** it is to be done (style and location). Your portrait samples will help to determine these features. They will allow you to explain the difference between a literal and an interpretive image. A literal image is one in which it is obvious that the subject is aware of the camera, as he or she is looking directly into the camera lens. The image will be a well-defined literal presentation of the subject that is "active" in nature.

An interpretive image is one in which the subject appears to be unaware of the presence of the camera. The subject is engaged in an activity or is viewed in an attitude of repose, not looking directly at the camera. The interpretive representation is far more "passive" in nature and is often preferred by

the client who is uneasy about displaying a literal portrait of himself or his family.

Finally, you will determine where the portrait will be made: in the camera room or at an indoor or outdoor location.

STEP FIVE: ADVICE ABOUT CLOTHING

One of the most important areas of client involvement is choosing clothing that will best suit the style of portrait you intend to make. No matter how well you light and pose a portrait, if the clothing is not right, the portrait will suffer, as will the sale.

For low-key work, suggest medium to dark tones of green, brown, burgundy, rust, blue, or gray, and warn clients to stay away from bold patterns, pastels, or any shades lighter than skin tones. Let them know this is essential if you are to

The examples shown above illustrate what an impact coordinated clothing can make in creating a portrait. These examples, among others, appear in the client preparation brochure, shown at right, which is a valuable resource in educating clients about clothing.
source: Marathon Press (800-228-0629)

succeed in making a portrait in which the face, not the clothing, is dominant. If you are discussing a high- or medium-key portrait, talk about proper clothing for each style. Finally, present examples of portraits that are spoiled because of improper clothing. This does more than anything to impress clients about the importance of proper clothing.

During the clothing discussion, inquire about opportunities to personalize the portrait. This could mean including a family pet, or portraying the family in an activity they enjoy. Generally, the more that clients become emotionally invested in their portraits, the more they are willing to spend on them.

STEP SIX: EXPLAIN YOUR PREVIEW PRESENTATION METHOD

If you plan to present previews through a projection method, inform clients about this during the planning session, taking time to explain the advantages of this selection method. It is important for clients to recognize that they will do the selection in your studio (or at their home, if you wish), with you or an employee present to assist with the selection itself, to explain retouching and finishing options, and to make recommendations about framing.

STEP SEVEN: HANDLING QUESTIONS ABOUT PRICE

If pricing was discussed with the client when the consultation session was booked, the subject may not come up again. If it does, however, handle it the same way you would during a telephone

one who is personally or jointly with a spouse or relative the buyer of the portrait; and one to whom price is not likely to be a major consideration in selecting the photographer. The most easily identified committed customers are those who express interest in portraits of families, children, pets, older couples, and executives—in short, anyone who has expressed the desire for a specific category of portraiture.

THE "UNCOMMITTED" CLIENT

The uncommitted client is one who is motivated by an external event (such as the publication of a yearbook or a request by a loved one to receive a portrait as a gift); one who is not necessarily the buyer of the portrait; and one for whom price may play a part. Such customers include individuals or couples who give the impression that they really are not sure what kind of portrait they would like to have. Usually these are persons who want a portrait as a gift for a parent or other loved one. Typically, their motivation for having the portrait made comes not from their own commitment to the idea, but rather from a desire to please someone else. High school seniors comprise the largest segment of uncommitted customers. They are motivated to seek senior portrait services by the need to have a yearbook portrait. In most cases parents are the buyers, and often price is a consideration.

For committed customers, it is best to predetermine at a planning session exactly what style of portrait you will create. At the portrait session, your goal should be to work for a good expression from a single pose, not to do a variety of poses. For committed clients, one of several projection methods of preview presentation is the best choice, in that your objective is to sell a wall portrait. Through projection, you have total control of the sale, and it is unquestionably the best way to assure the sale of wall portraits.

For uncommitted customers, the paper preview method of presentation is a good choice. Uncommitted customers respond well to a variety of poses, and the sale is built through multiple-print orders. Within the selection of poses there is nearly always something that appeals to the client, his or her parents, relatives, and friends, thus increasing the number of buyers.

One of the characteristics of uncommitted customers is that price often is a consideration in their purchase decision. One way to maximize your sale with these clients is to present an "incentive" price list (see Chapter 7) that provides a price break to those who place multiple-print orders. Remember, the purpose of such a price list is to surmount the problem posed by the high cost to the business of the first-unit-sold. The client receives a better value, and the business derives the profit necessary to justify selling at the lower price. Many clients tend to spend more when they can see that it is financially advantageous to purchase in greater volume.

Choosing the "Best" Preview Method and Sales Presentation

Photographers today have a host of preview presentation methods and accompanying sales systems to choose from—a far cry from the days when photographers went to their darkrooms and printed black-and-white "proofs" that faded with age. Each of these methods has advantages for both the photographer and the client; and there is no single, "best system." Your choice of method should depend on what best facilitates the sale. This means that you might choose the paper preview method for one product line (such as high school seniors), the slide-projection method for another (such as family portraits), and perhaps electronic previews for special offerings (such as children's promotions).

Preview Presentation Methods

PAPER PREVIEWS

Most clients are familiar with this method of preview presentation and sales, as it has been around since the dawn of professional photography. When placed in a leatherette folio, such as the one shown at right, the result is a pleasing presentation that showcases the variety of poses and settings that the photographer can create. Because it can be taken away from the studio, the folio can be viewed by all potential buyers in the family, and it also serves as a good promotional device. In the case of

high school senior portraiture, for example, the subject can take his or her portrait previews to school to show friends, thereby promoting your photography in the process.

ELECTRONIC PREVIEW PROJECTION

Several approaches to electronic preview presentation include:

- **Digital capture and projection** — Images are made with a digital-capture camera that sends images to a computer connected to a monitor or to a digital projector. The advantages of this system include instant viewing, and in the case of the digital projector, large image sizes can be shown. If using a monitor for viewing, the image size is limited to the size of the monitor, and with either scenario there is some loss of image detail.
- **"Instant proofing" devices** — These systems consist of a traditional camera wedded to a video camera that is synchronized to record a duplicate image at the moment when the film-camera shutter is tripped. Clients can then view the video previews on a television screen. Again, the advantage is instant viewing of the session images; however, the viewing size is limited by the screen size of the TV monitor, and there is some loss of image detail.

One of the most professional methods of paper-preview presentation is in a multiple-pose leatherette folio. The folio presentation is itself so attractive that it leads to increased profits through selling the folio and its previews. It is a good promotional tool because the subject is inclined to carry it to school or to work, where other potential customers have the opportunity to view the photographs.
Source: Art Leather Manufacturing Co. (800-88ALBUM)

- **Reversal projection of negatives** — In this method of projection, processed film is viewed through a video system that reverses the negative image to a positive one that is viewed on a television monitor. This system is often used by wedding photographers to preview the wedding when selecting images to print for client presentation, thus saving money on preview costs. Some photographers use the system as their primary means of preview presentation. There is some loss of image detail with this technology.
- **Opaque Projection** — This system allows the photographer to project a paper preview onto a screen and display it in various sizes. This equipment requires that the room be completely dark, and there is some loss of image fidelity.

TRANSPARENCY PREVIEWS

This is an effective and popular method of projection, as the only major investment required is for a projector and lens capable of projecting a range of image sizes. Image fidelity also is a significant advantage, in that the image retains its integrity, even in the largest projection sizes.

SPECULATION PURCHASE

Mass-market photographers have used this presentation method successfully for decades. The manager selects the best image or images and prints whatever numbers of finished units are likely to be purchased by the client, based on business experience. Usually there is a price incentive to purchase all of the units. Typically, this method works best in selling smaller-size portraits at the lower end of the price spectrum, although some mid-price-range studios will sometimes print a wall-size image as speculation with selected clients.

PRESELLING THE PORTRAIT

A very few photographers at the upper end of the price scale conduct their portrait and wedding businesses by commission. With portraiture, this process usually involves a visit to the client's home to view where the portrait will hang. The price is agreed to prior to the photography session, and in many cases it is up to the photographer to select the portrait image. In effect, the photographer is

conducting business just as a portrait painter would do. This form of selling requires a great deal of confidence, sophistication, and artistry on the part of the photographer.

In the case of weddings, the client agrees to a price that covers the photography and production of the bridal album, with the photographer being responsible for the design of the book. As is the case with preselling portrait photography, this way of doing business requires the photographer to gain her client's complete confidence and trust in her artistic abilities.

Projection vs. Paper Previews

Photographers who have never used projection of any kind often express concern that customers will resent having to come to the studio to see their previews. Experience proves that this is not the case, as long as the client knows in advance that she will be viewing previews in the studio. That way she can arrange to have all interested parties present. Many clients actually prefer the projection method. What many photographers do not recognize is that choosing the right portrait is often a burden for clients. They value and appreciate input and support in helping to make a decision.

The process of choosing a pose takes only a fraction of the time consumed when using paper previews, because the client is forced to focus complete attention on the screen while the various images are compared. As a result, the presenter can spend more time helping the client decide on an appropriate size, finish, and frame, rather than assisting one who is struggling to choose the best image from a pile of proofs. Since selling by projection is accomplished by a process of elimination, the client feels more comfortable and confident about the image selected.

The advantages of presenting portrait previews by projection are many, the most important being that it enables the photographer to sell large wall portraits in nearly every sales session. The seller has complete control of the sale and can calm any anxiety about retouching or other corrections. Should there be a problem with the previews, another session can be scheduled. A sale is never

lost because proofs are not returned or a client is unhappy with the results of the sitting.

Large portraits are particularly easy to sell because the client never sees the image in 4 x 5 proof size. So when it is time to decide on size, the client is acclimated to the large projected image, and smaller sizes look less appealing. The salesperson can direct the size choice by discussing where the portrait will hang and showing similar situations in the studio. Projection also presents an excellent opportunity to sell frames, because different frames can be held over the projected image to demonstrate how the framed print will look.

Selling by projection is especially helpful for wedding photographers. The wedding album aside, much of the photography's value comes the **enjoyment** of the proofs. When wedding previews leave the studio, viewers get to enjoy them at no charge, and the photographer is short-changed on his sale. With projection, if the couple elects not to have a photograph in the album or as an extra print, it simply "goes away." Thus, if the couple or family members want to continue enjoying the image, they have to purchase it. Most photographers who move

Advancements in album-design computer software applications not only save album production time, they also allow wedding clients to preview how their photographs will appear in the finished album, as is the case with the Montage™ software system shown here (See Appendix).

Source: Art Leather Manufacturing Co. (800-88ALBUM)

from paper-proof presentation to projection experience an immediate doubling of wedding sales. They find, also, that their ability to sell wall decor from candid wedding photographs is greatly enhanced through the projection method.

This does not mean that paper previews should never be used. If you are confused between the two types of presentations, reread the definition of the "uncommitted client" on page 100. With this type of customer, you can create an attractive and profitable presentation by using an incentive price list with paper previews in a leatherette folio.

Some wedding photographers who prefer to use paper proofs succeed in maximizing their sales by hosting a "design session" at the studio, where they can maintain control of the sale. This, too, is an excellent profit-producing strategy. Remember that when wedding previews leave the studio, they will be passed around to interested parties who can satisfy their need to enjoy seeing the pictures without having to purchase any. This, more than any other factor, will dilute the size of the sale to which the photographer is duly entitled because of the time and expertise he or she has put into photographing the event.

Practice Makes Perfect!

Whatever method or methods you decide will maximize the sales of your products, you will never realize their full potential without practice. It takes the same kind of time and practice to refine selling skills that it does to perfect photographic techniques. Many photographers find that successful selling is difficult to master, probably because as creative people they feel awkward when having to translate the value of their art into dollars. This is especially true when they are faced with clients who are concerned about price. The photographer who is inhibited about selling can overcome this obstacle by strengthening her belief in the value of her product. Preparing and studying a sales "script" can help to improve the photographer's comfort level. Another option is to attend sales-training seminars offered by numerous management organizations.

If you are not willing to overcome a dislike for selling, then to hire a person who excels at it. If not, your business will forever be handicapped and possibly even fail.

The Order-Decision Process

Whatever sales presentation you use, it is helpful to keep a step-by-step decision process in mind to make certain that you cover all possibilities for sales. These steps include:

• Portraits for the client's personal use at home or for the office
• Gift portraits — Stress that it is never too early to order portraits for holiday gift-giving.
• Wallet orders for friends and relatives
• Accessories such as holiday cards
• Framing for personal and gift portraits
• If paper previews are used, demonstrate creative methods for framing the previews.
• If appropriate, discuss the likely timing for the next portrait service the individual or family will need, and make a note to call and suggest an appointment when that time comes.

Methods of Payment

In today's culture, it is common for people to purchase more than they originally thought they could "afford": A house budget of $100,000 becomes a purchase of $125,000; a car budget of $12,000 becomes a purchase of $15,000. This happens because either the buyer becomes emotionally involved in the purchase or is willing to spend more after being sold on the additional value that will be received from the higher price.

It is likely that you will be successful in selling many orders for sums larger than the buyers might originally have intended to spend. There is nothing wrong with this, provided that you did not intentionally over-sell with aggressive tactics. To facilitate larger sales, you should accept credit cards, as they, too, have become an integral part of the culture. Generally, it is not wise to let a client receive finished work without payment in full; otherwise you are risking the possibility of having to engage in time-consuming collection procedures that will be irritating both to you and the client.

Post-Sales Presentations

Smart marketers recognize that the pick-up appointment represents another opportunity for sales that can be generated by photographic accessories or special offers. It also provides another chance to discuss when the next photographic event is likely to take place or even to gain referrals from obviously delighted clients.

Even the happiest customer, however, can be subject to a phenomenon known as "post-purchase dissonance" or "buyer's remorse"—a kind of letdown that follows the shrinking of one's wallet when a final payment is rendered. To help counteract this possibility, give the client a "courtesy folder" with his completed order—similar to the client information folder you provided prior to the session.

Include a "registration" document that explains the value of the product just purchased (see example below). Suggest that it be retained for insurance purposes. Other items for the folder might include information on proper care of the portrait to guard against fading, as well as promotional brochures about other studio products, and any "for clients only" or "frequent-buyer" specials you might offer.

Another very effective post-sales courtesy is to mail clients an inexpensive gift, along with a thank-you note, a week or so after the transaction is completed. The gift could be a decorative wallet-size frame or a selection of note cards containing wallet images from the client's portrait session (see page 56). This will help to strengthen your ties with valuable clients whom you want to have as repeat customers. Even though you might not see that client every year, keep mailing your promotional material. Remember—if you don't, someone else will, and when your client once again needs photography services, it's your business that will come to mind!

The "Portrait Registration" certificate shown here was created using the same materials as the client information folder (see page 44) to maintain an image of graphic continuity.

source: Marathon Press (800-228-0629)

Tracking Business Progress

Jun	Jul	Aug	Sep	Oct	Nov	Dec
11,765	14,140	11,725	11,025	15,000	10,340	11,165
300	300	300	300	300	300	300
3,000	3,000	3,000	3,000	3,000	3,000	3,000
3,600	3,600	3,600	3,600	3,600	3,600	3,600
150	150	150	150	150	150	150
0	300	0	0	3,000	0	0
50	50	50	50	50	50	50
300	900	0	0	0	0	0
1,000	1,000	1,000	1,000	1,000	1,000	1,000
150	200	150	150	200	150	150
2,225	1,025	2,485	1,785	1,785	1,025	1,625
0	125	0	0	125	0	0
100	100	100	100	100	100	100
0	1,700	0	0	0	75	300
0	800	0	0	800	0	0
20	20	20	20	20	20	20
100	100	100	100	100	100	100
40	40	40	40	40	40	40
80	80	80	80	80	80	80
150	150	150	150	150	150	150
500	500	500	500	500	500	500

9/14/98 8:06AM

*T*oday, the lifeblood of any business is information. Without accurate information that allows you to track the performance of your most critical business functions, you will be unable to make the informed management decisions that ensure business success. All successful business—large or small—know this to be true. The challenge, however, is much more difficult for the small business in which so many functions are performed by so few people. That is why it is essential for photographers to make use of technological tools that improve both their productivity and profitability.

The Importance of Computers

The advent of personal computers has made it possible for small businesses to possess the same business information that years ago would have required the work of several clerks and accountants to provide, at a small fraction of the cost. Furthermore, the very same computer that processes financial and client information can be used to generate mailing labels for mass mailings; as a desk-top publishing device to create marketing materials; as a letter-writing tool to generate personalized correspondence; and it can function as a project-organizer and appointment-scheduler. Finally, it can be used as part of a system for photographic retouching, and image-manipulation; to receive digital images from digital-capture cameras; and to output images to printers or film-recorders. Today, a fully functioning computer system, equipped with appropriate software, is as important to a photography business as a camera and lighting equipment.

It is a mistake to believe that a new business doesn't need a computer until it has lots of clients: It is best to begin recording client information and financial data from the very beginning. It is also foolish to believe that a business is "too old" to benefit from computerization because of the difficulty of entering years of client records into a system. If yours is an older business, simply enter your current clients.

- Insurance (Building, not equipment or auto)
- Property tax

V. Cost of Obtaining Business
- Advertising (Include postage for mailings.)

VI. Administrative Costs
- Postage (Occasional - not advertising)
- Telephone
- Props and camera costs (Cost of small budget props and camera accessories. Include camera insurance and camera maintenance here.)
- Office expense (Items needed for administrative purposes)
- Education expense
- Travel & entertainment (If travel is done only in conjunction with educational activities, then charge to "Education expense" and do away with this category, as it is a favorite target of I.R.S.)
- Interest
- Auto expense (Include auto insurance here.)
- Accounting & legal
- Miscellaneous

VII. Capital Asset Expense
- Depreciation (For more information on depreciation, review the material on page 28.

STEP THREE: COMPILING INCOME & EXPENSE PROJECTIONS

Once projected income and expenses are entered into your business plan software, it will automatically provide you with an Income & Expense Budget that paints a vivid picture of your business finances. For first-time business planners, the picture does not always reflect desired profitability. That is precisely why the plan is so important: It provides the basis for fine-tuning the business. Typically, these changes must occur in the income side, assuming that expenses have been realistically budgeted. Increases in income can come via three methods: price increases, improved sales systems, or increased marketing and promotion that results in additional business.

In the Income & Expense Budget illustration shown on page 111, you will note that Cost of Sales is automatically computed according to the Cost of Sales percentage factor (COS) that it is up

to you to establish. To review the elements that affect this important factor, see the information on pages 80-81.

Cost of Sales is then automatically subtracted from Total Sales to compute Gross Profit—the amount left over when the cost of product manufacture is subtracted. Total General Expenses are then subtracted from Gross Profit to reflect the Net Profit of your business.

After calculating your beginning or "trial" budget, you can develop marketing, pricing, and sales strategies as you simultaneously reconcile the financial effect they will have on your income and expenses, all toward the goal of deriving desired compensation for yourself and an appropriate profit for your business. (For information on determining an appropriate net profit, review the "Investing in Your Business" section on page 25.)

As you begin mapping out marketing, sales, and pricing strategies to increase your income, you can update the Income & Expense Budget by going back to the Sales & Sessions Projection, where you can revise these numbers upward to reflect the strategies you intend to put in place. Should you find areas where General Expenses can be trimmed, then you can revise these numbers downward by returning to the Expense Budget. All changes will be reflected automatically in the Income & Expense Budget report. It is through this process that you gain not only a better understanding of the financial aspects of your business, but also you begin to take control of the management of your business.

The process is facilitated when you understand the concept of "break-even analysis." Through the break-even formula, you can determine exactly what level of income or "gross sales" is necessary for your business to break into the profit column. The formula is as follows:

$$\frac{\text{Total General Expenses}}{100\% \text{ minus COS}\%}$$

The examples that follow on page 112 not only show the break-even formula at work in the case of two different businesses, they also compare the impact of Cost of Sales percentages on the level of sales that must be achieved to become profitable.

Income & Expense Budget

	TOTALS	% of Sales	Jan	Feb	Mar	Apr	May	Jun	Jul	Aug	Sep	Oct	Nov	Dec
Total Sales	266,780	100.0%	14,600	17,750	25,950	19,000	18,850	19,725	15,650	17,575	22,775	27,945	37,500	29,460
Cost of Sales	83,153	31.2%	3,865	5,810	4,770	5,400	5,700	6,562	4,545	5,092	9,397	12,808	13,450	5,752
Gross Profit	183,627	68.8%	10,735	11,940	21,180	13,600	13,150	13,162	11,105	12,482	13,377	15,136	24,050	23,708
General Expenses	146,265	54.8%	15,080	11,755	10,265	12,540	11,465	11,765	14,140	11,725	11,025	15,000	10,340	11,165
Net Profit	37,362	14.0%	-4,345	185	10,915	1,060	1,685	1,397	-3,035	757	2,352	136	13,710	12,543

General Expenses	% of Sales	Business Function
39,600	14.8%	I. Owner's Compensation
43,200	16.1%	II. Employee Expense
1,800	0.6%	III. Services you buy from people not on your payroll
19,700	7.3%	IV. Overhead expenses associated with your place(s) of business
21,860	8.1%	V. Costs associated with bringing business into your studio
14,105	5.2%	VI. Administrative costs - cost of doing business in any location
6,000	2.2%	VII. Depreciation

Owner's Compensation + Net Profit	76,962.00	28.8%

The Income & Expense Budget shown above automatically combines a summary of the figures presented in the Sales & Sessions Projection and the Expense Budget shown on page 109. Cost of Sales is computed automatically according to the designated Cost of Sales percentage for the business. Of particular note is the last computation (Owner's Compensation + Net Profit), which expresses this vital figure both in terms of dollars and as a percentage of total sales.

Source: Success Planning application of SuccessWare® (800-593-3767)

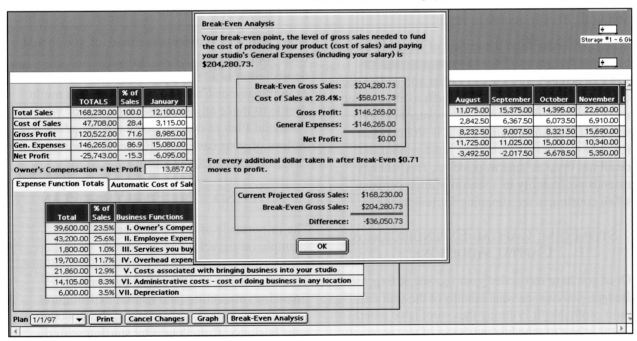

Break-Even Analysis, a helpful tool used to determine the total of sales that must be achieved in order for a business to become profitable, is an automated feature of SuccessWare. In this example, the business would have to do an additional $36,050.73 in projected sales before breaking into profit.

Source: Success Planning application of SuccessWare® (800-593-3767)

Fine-Tuning Your Business Plan

Your annual business planning must begin early in the fourth business quarter to assure that next year's marketing strategies are in place when the new year begins. Accordingly, the last three months of your financial projections must be based on anticipated outcomes for financial performance that cannot be confirmed until these three months are completed. So it is important to review the financial projections of your business plan—relative to actual year-end financial performance—as soon as books are closed for the year. If any changes to the financial plan are likely to affect promotional or advertising plans for the coming year, then both the marketing plan and calendar should be revised as well.

Integrating Data Base Management With Financial Management

When your new year begins with a Business Plan in place, you are in a position to take control of other important business management functions. These include:
• Data Base Management
• Order Management
• Income Tracking
• Bank Account Management
• Bill Paying
• Expense Tracking
• Monitoring Your Financial Position
• Monitoring Workflow
• Adding Prospects and Monitoring Inquiries

Today's studio owners save valuable administrative hours through the use of integrated software that shares information between the data base and financial components. Thus, time-consuming double and triple entry of the same data is not necessary, and the chance of mistakes in computation are reduced.

It is hard to imagine why a photographer would want to manage a data base or perform accounting tasks by hand, but whether these functions are performed by computer or by hand, it is critical for the business to adopt a "managerial" system of accounting.

The Importance of Managerial Accounting

Photography is known as a "passion business," one in which the principals typically are more interested in their art than in the activities necessary for the business to survive. One reason why many studio owners shun the business side is that they find conventional accounting methods to be a chore that yields very little data for making management decisions. This is an unfortunate consequence of the owner's not understanding that what he or she requires is **managerial** accounting rather than **custodial** accounting. "Custodial" accounting refers to the collection and interpretation of information necessary to determine tax liability to various federal, state, and local government agencies. This information is virtually useless in helping you to understand your business. It is "managerial" accounting that serves this purpose.

Unfortunately, many photographers, because they lack an understanding of the types of management data required for business decision-making, simply rely on a custodial accountant to set up their bookkeeping structure. This is a critical management error because an accountant is unlikely to know what information is needed to make profit-minded business decisions in the photography industry.

The industry standard for data collection and reporting was developed in the 1960's by Charles H. "Bud" Haynes, Hon.M.Photog.Cr, A-ASP, former president of the Professional Photographers of America, Inc. and the Photographic Arts and Science Foundation. I have updated these standards to reflect the impact of ensuing years of inflation, and developed managerial "function" categories that are listed in the business planning section (pages 108-110) of this chapter. They are again displayed in the Income & Expense Statements shown on page 124. These are the standards that are incorporated into SuccessWare,® the only fully integrated studio management software program available for the portrait/wedding studio. All SuccessWare illustrations in this chapter are based on managerial accounting principles and employ a "pure cash" system of accounting.

Data Base Management

While all businesses must constantly attract new customers, smart business people understand that it is far more profitable to do as much business as possible with existing clients, because it costs much less to sell to an existing client than it does to attract a new one. Another important advantage of striving for a loyal client base is that happy clients will refer their friends and family members.

Effective "relationship marketing" depends on shrewd data base management, which includes storing and reporting on the following important bits of client information:
- Personal information about the client
- Information on the client's family and friends
- Information on sessions performed for the client
- Information on all orders placed by the client

Once this information is stored, as seen in the data entry windows on this page, it can be accessed for a variety of marketing purposes.

These data-entry and display windows show how a variety of important client information data can be entered and viewed.

Source: Success Tracking application of SuccessWare® (800-593-3767)

Order Management and Income Tracking

The first step in managerial accounting is to adopt a "pure cash" system of accounting. Under this system there is no such thing as a "deposit" and the accounting difficulties it creates. You deal only with "payments." Whether a client pays a session fee, a wedding photography reservation fee, a down-payment on a portrait, or the balance of an order being picked up, you will account the money received in the same manner: It is a sale—a sale accounted to the product line that produced it.

RECORDING SALES BY HAND

Although many photographers use computers to accomplish their accounting tasks—including order entry that generates computer-printed invoices—some continue to use a paper invoice form to record details of the order, so as not to put a computer between themselves and their clients. Later, they transfer the information to the computer.

The 5.5" x 8.5" paper form shown at right serves as a Sessions/Sales/Invoice record. It consists of the following parts:

Section 1 records pertinent client information.

Section 2 records the session number of the sitting, using a four-digit numerical code that is prefixed with a single digit which increases to 2 after the code reaches 1-9999. The following number, then, would be "2-0001." Next to the session number box is a place to circle what type of previews to order.

Section 3 provides space to record dates and amounts of payments made.

Section 4 is the "order tracking" record.

Section 5 indicates which product line and product category this session applies to. In Chapter 2 you learned to establish product lines according to the Product Line list on page 18. This section of the form is personalized with your specific product lines.

Section 6 is the area where the order is recorded at the time it is placed.

Section 7 allows you to make notes about retouching or any miscellaneous information about the order.

Section 8 provides both a model release and a verification of the order. It obligates the client to make the final payment "on completion" (on the date notified by the studio), 30 days after which interest is assessed.

The hand-entry invoice shown above is an appropriate choice for salespeople who prefer not to place a computer between themselves and clients. Order information can be entered into the computer later. Shown at right is the computer-generated version of the same invoice.

The form consists of three copies. For studios filing by hand, the top copy (white) is the permanent file record used to track the order through its various stages of processing and ultimately filed for future reference. The second copy (yellow) eventually is filed with negatives, but can be attached to the order for reference when performing any tasks done in-house. The final copy (pink) is the client's receipt, given to her when the order is placed.

RECORDING SALES BY COMPUTER

Whether sales are recorded by hand initially and the data later entered into the computer, or the process accomplished entirely by computer, integrated data allows you to record, view, and print reports of the following:
- Order Details
- Ordered Items
- Payments Made / Invoicing
- Workflow Tracking

These functions are shown in the screens at right.

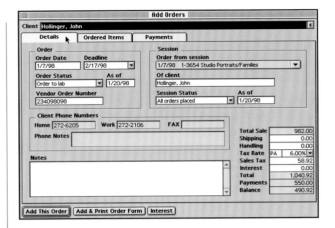

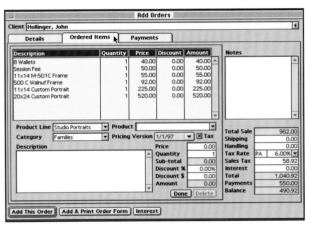

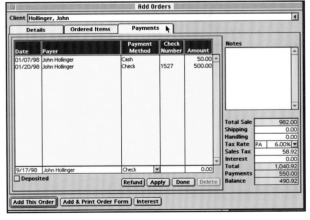

This series of windows shows important information about both the order itself and the method and disposition of the client's payment. The computer-generated order form is shown at left.

Source: Success Tracking application of SuccessWare®
(800-593-3767)

SALES AND SESSION REPORTING

One of the great advantages of fully integrated data base and financial software is that once you have recorded information about your clients and the sales they have generated, sales and sessions reports are automatically compiled for whatever period you desire. This not only saves time in obtaining the report, it also ensures accurate computations. And the same report that provides this managerial information can be used for tax-preparation purposes.

Sales Report

For Sales during February 1997.

Product Line Category	This Month		This Year To Date		Last Year	
	Sales	% of Total	Sales	% of Total	Sales	% of Total
TOTALS:	21,840.00	100%	39,309.00	100%	3,100.00	100%
Promotions	14,538.00	67%	21,134.00	54%	0.00	0%
"5 Ways"	1,255.00	6%	4,187.00	11%	0.00	0%
--NONE--	0.00	0%	69.00	0%	0.00	0%
Bunny	12,058.00	55%	12,058.00	31%	0.00	0%
White Sale	1,225.00	6%	4,820.00	12%	0.00	0%
Studio Portraits	0.00	0%	8,473.00	22%	0.00	0%
Couples	0.00	0%	1,200.00	3%	0.00	0%
Families	0.00	0%	7,273.00	19%	0.00	0%
Weddings	7,302.00	33%	9,702.00	25%	3,100.00	100%

Session Report

For sessions during February 1997.

Product Line Category	This Month			This Year To Date			Last Year	
	Goal	Actual	% of Total	Goal	Actual	% of Total	Actual	% of Total
TOTALS:	63	46	100%	91	69	100%	0	0%
Frames/Accessory	0	0	0%	0	0	0%	0	0%
Promotions	55	40	87%	75	57	83%	0	0%
"5 Ways"	10	0	0%	20	8	12%	0	0%
Bunny	45	32	70%	45	32	46%	0	0%
Kid Contest	0	0	0%	0	0	0%	0	0%
White Sale	0	8	17%	10	17	25%	0	0%
Xmas Cards	0	0	0%	0	0	0%	0	0%
Seniors	0	0	0%	0	0	0%	0	0%
Central Hs	0	0	0%	0	0	0%	0	0%
City Hs	0	0	0%	0	0	0%	0	0%
Midland Hs	0	0	0%	0	0	0%	0	0%
Northern Hs	0	0	0%	0	0	0%	0	0%
Southern Hs	0	0	0%	0	0	0%	0	0%
Service Sessions	2	0	0%	2	0	0%	0	0%
Studio Portraits	4	4	9%	11	8	12%	0	0%
Brides	0	0	0%	0	0	0%	0	0%
Children	2	2	4%	2	2	3%	0	0%
Couples	0	1	2%	0	2	3%	0	0%
Executives	1	0	0%	1	0	0%	0	0%
Families	1	0	0%	3	3	4%	0	0%
Individuals	0	0	0%	1	0	0%	0	0%
Pets	0	1	2%	4	1	1%	0	0%
Weddings	2	2	4%	3	4	6%	0	0%

Automatic Sales and Session reports provide important managerial data when accounted by month and product line.

Source: Success Tracking application of SuccessWare® (800-593-3767)

Bank Account Management

Once you have begun to collect money from customers, you must have bank accounts to serve several business purposes. Experience shows that most studios require three types of accounts: a regular checking account, a limited checking account that pays maximum possible interest, and a money-market account. Proper management of these bank accounts will help you to keep an eye on your business cash flow. Following is a description of the uses of each bank account:

REGULAR CHECKING ACCOUNT — All monies resulting from sales, borrowed capital, etc. are deposited into this account, and all business expense checks are written on it.

LIMITED CHECKING ACCOUNT — Once each week, write a check from your regular checking account to this account in the amount of sales taxes collected. Once each pay period, write a check from regular checking for the amounts of any employee withholding and employer's matching Social Security payments. Doing this will keep you up-to-date with tax payments that have a way of creeping up on you, and the absence of these funds from your regular checking account will place a subtle psychological pressure to keep working for new business to cover these expenses.

Many good business people use this account for another purpose— as the repository for funds to pay their lab and supplier bills, since these bills usually are the largest recurring liabilities a studio owner incurs. More than one studio has gone bankrupt because too many such bills piled up. You can avoid this pitfall by taking each sales deposit and multiplying it by your Cost of Sales percentage, then writing a check for that amount to your limited checking account. The money to pay these suppliers, then, is put safely away, and the

balance left in your regular checking account reasonably approximates your firm's capacity to meet its General Expenses. A small balance in the regular checking account serves as an excellent motivator for many business owners to be more aggressive in obtaining new business.

MONEY-MARKET ACCOUNT — The best way to recapture any personal business investment is to write a monthly check for the amount of your depreciation allowance. This will safeguard the funds and place pressure on your business to cover the expense—in effect paying yourself back for personal funds invested. Depreciation funds are deposited in this account.

The table below is a ready-reference to the three accounts and the sources of their funds:

BUSINESS ACCOUNTS

Regular Checking Account

- All cash receipts
- Any borrowed funds

Limited Checking Account

- Sales tax
- All employee withholding
- Employer matching Social Security contributions
- Sufficient funds to cover Cost of Sales items

Money-Market Account

- Monthly depreciation allowance

Note: Checks to cover all business expenses are written from Regular Checking Account only. Funds from other accounts are transferred to Regular Checking Account when needed.

As you can see from the illustration above at right, automated software is a great bank account management time-saver. Multiple accounts can be managed with one application, and mathematical calculations are automatic, assuring accuracy and greatly facilitating check-book reconciliation.

Modify Accounts

Checking Account: Regular Checking - 54673

Date	Cleared	Check No.	Description/Payee	Amount	Balance
1/1/97	X		Beginning balance	12,235.34	12,235.34
1/3/97	X		Visa deposit	5,154.18	17,389.52
1/5/97	X		Deposit	1,000.00	18,389.52
1/9/97	X		Deposit	300.00	18,689.52
1/10/97	X		Visa deposit	497.37	19,186.89
1/10/97	X		PPA M&M Convention	-425.00	18,761.89
1/12/97	X		Deposit	750.00	19,511.89
1/12/97	X		Visa deposit	490.50	20,002.39
1/15/97	X	551	John Smith	-3,000.00	17,002.39
1/15/97	X	500	AA Accounting Service	-125.00	16,877.39
1/15/97	X	2148	Marathon Press	-1,625.00	15,252.39
1/15/97	X	2149	City Mall, Inc.	-125.00	15,127.39
1/15/97	X	2150	Galleria Corp.	-200.00	14,927.39
1/15/97	X	2151	Old Town News	-400.00	14,527.39
1/15/97	X	2152	Marathon Press	-200.00	14,327.39
1/15/97	X	2153	Elegant Bride	-100.00	14,227.39
1/15/97	X	2154	Wedding Expo 97	-500.00	13,727.39
1/15/97	X		Mobil Oil	-72.14	13,655.25
1/15/97	☐	2155	John Smith	-500.00	13,155.25
1/15/97	X	2156	Susan Harold	-700.00	12,455.25
1/15/97	X	2157	Helen Trainer	-1,100.00	11,355.25
1/15/97	☐	2158	Acme Insurance Co.	-298.00	11,057.25
1/15/97	☐	552	First National Bank	-435.00	10,622.25
1/15/97	☐	2161	Ace Plumming and Heating	-756.00	9,866.25
1/15/97	☐		Staples	-89.00	9,777.25
1/15/97	☐	2162	Molly Maids	-50.00	9,727.25
1/15/97	☐	2163	Joe's Auto Repair	-140.00	9,587.25
1/15/97	☐	2164	Aetna	-328.00	9,259.25
1/15/97	☐	2165	UPS	-35.00	9,224.25
1/15/97	☐		USPS	-32.00	9,192.25
1/15/97	☐	2166	Albert H. Wholers, Insurance	-240.00	8,952.25
1/15/97	☐	2167	Atlantic Camera Repair	-56.00	8,896.25
1/15/97	☐	2168	Don Blair	-30.00	8,866.25
1/15/97	☐	2169	Fancy Flowers	-56.00	8,810.25
1/15/97	☐		John Smith	-1,000.00	7,810.25
1/15/97	☐		Bell Atlantic	-118.00	7,692.25

Go To Regular Checking ▼ | Reconcile | ☐ Place logo on printed checks

| Delete Account | Clear | Deposit | Interest | Modify Logo | Print |
| Delete | Unclear | Withdrawal | Transfer | Check Transfer |

SuccessWare manages any number of accounts including checking, credit cards, and loans.

Source: Success Tracking application of SuccessWare®
(800-593-3767)

Bill Paying and Expense Tracking

Bill paying and monitoring expenses is one of the most important functions of any business, and they are among the most critical to manage within a framework of business discipline.

BILL PAYING / EXPENSE DOCUMENTATION

Bill-paying discipline involves two requirements: Bills must be paid on time, and an invoice of some kind is necessary to document each expense. If you are short of cash during an "off month," it is better to borrow from a reasonable line-of-credit account than it is to let bills pile up month after month. The interest paid on your line-of-credit should be viewed as a necessary cost of competing in a business that is somewhat seasonal in nature. To avoid risky debt, you should establish a limit as to what constitutes reasonable borrowing.

Having an invoice or receipt to verify each business expense (goods or services) is not only good discipline, it also is vital should your business be audited by IRS or your state. Without substantiation, expenses can be disallowed.

Some purchases require even further documentation when you are under audit. Assume, for example, that you purchased a dining room table and chairs from a furniture store for use in a conference room. The invoice probably will say "dining room table and chairs," and this is just the type of purchase that will look suspicious to an IRS agent, who is likely to conclude that you are charging personal items to your business. To substantiate the expense, you can make a picture of the furniture in the business as proof of its use.

When drawing from a petty-cash fund, be sure to make a note of each withdrawal and its purpose, since many petty-cash transactions will not have invoices to back them up. This record will suffice as evidence of these minor expenditures.

Expense Tracking

Before the arrival of automated software, paying bills and recording these expenses was a burdensome chore. Today, that burden is greatly eased through automated bill paying that simultaneously records expenses to the proper expense line item. Expense reports, which provide both managerial information and serve to fulfill tax-preparation requirements, are then automatically generated.

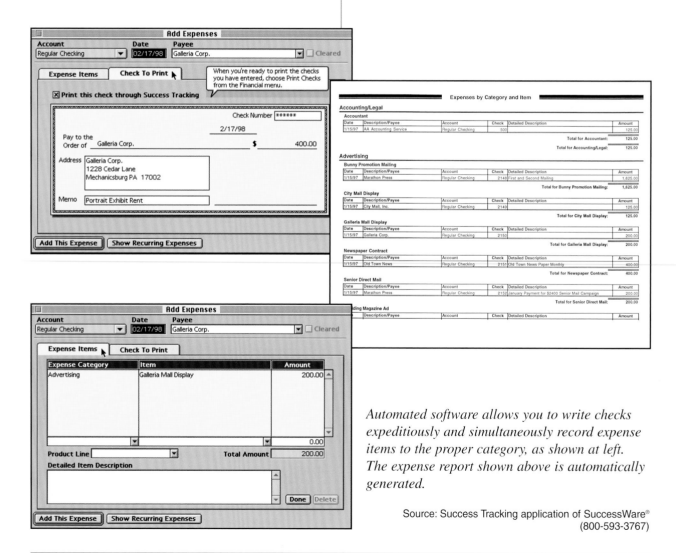

Automated software allows you to write checks expeditiously and simultaneously record expense items to the proper category, as shown at left. The expense report shown above is automatically generated.

Source: Success Tracking application of SuccessWare®
(800-593-3767)

Monitoring Your Financial Position

Of all the reports produced by studio management software, the most important is the monthly Income & Expense Statement. It is from this document that you learn how your business is performing, allowing you to make informed managerial decisions. Without it, you simply cannot take charge of your business.

This vital report establishes the relationship between business income and expenses that results in either profit or loss. Because it is linked to the Financial Plan portion of your annual Business Plan, it shows how the business is performing relative to the income, expense, and sessions projections for the year. At any given time during the business year, you will know precisely where the business is succeeding and where it needs improvement. This allows you to take action at the first sign of problems, rather than recognizing them only when it is too late to act.

Over the longer term, the most helpful information gained from the Income/Expense relationship is how the Cost of Sales, Gross Profit, General Expenses, and Net Profit are expressed as a **percentage of Total Sales.**

That relationship is presented in the model below—the same model to which you were introduced on pages 80-81 of the chapter on pricing. The model is expressed using two different Cost of Sales factors—30% and 40%.

Example 1:

Total Sales	100%
— Cost of Sales	30%
Gross Profit	70%
— General Expenses	60%
Net Profit (Loss)	10%

Example 2:

Total Sales	100%
— Cost of Sales	40%
Gross Profit	60%
— General Expenses	50%
Net Profit (Loss)	10%

Let us review what this relationship means: The first example shows that for every dollar the studio takes in, 30 cents (or 30 percent) is used to manufacture the product, 60 cents (or 60 percent) is spent on General Expenses, and 10 cents (or 10 percent) remains as profit.

The second example shows that for every dollar the studio takes in, 40 cents (or 40 percent) is used to manufacture the product, 50 cents (or 50 percent) is spent on General Expenses, and 10 cents (or 10 percent) remains as profit.

The Cost of Sales (the amount of each dollar spent to manufacture the product) of most portrait/wedding photography businesses falls somewhere between 30 percent and 40 percent. Those with higher General Expenses must, of necessity, work at the lower end of the range in order to have more of each dollar of sales available to pay the higher General Expenses. Each business owner must determine this Cost of Sales target based on his or her costs and the desired level of profit. Once established, this percentage becomes the first line of financial discipline. When you see Cost of Sales rising above the desired percentage, then you must take action to reduce the cost of your "manufacturing" process **or** raise your prices.

When you learn to monitor the "line item" percentages shown on your Income & Expense Statement, you will find them to be of as much or more interest than the dollar amounts shown. You will see clearly where your sales come from in terms of percentages, as well as the important Cost of Sales percentage relationship and the various percentages of each General Expense category. You will soon recognize that as any expense percentage increases, the effect is to decrease the percentage of Profit. These percentages are vital for diagnosing business problem areas.

On the following page, you will see this theory at work in an actual Income & Expense Statement.

Income & Expense Statement

MONTHLY REPORT MONTH: <u>February</u> YEAR: <u>1997</u>

RECEIPTS	This Month Goal	This Month Actual	Year to Date Goal	Year to Date Actual	% of Sales	SESSION RECORD — This Month Goal	This Month Actual	Year to Date Goal	Year to Date Actual
Frames/Accessory	0.00	0.00	0.00	0.00	0%	0	0	0	0
Promotions	8,500.00	9,503.22	12,250.00	13,006.52	39%	55	40	75	57
Seniors	0.00	0.00	0.00	0.00	0%	0	0	0	0
Service Sessions	0.00	0.00	0.00	0.00	0%	2	0	2	0
Studio Portraits	1,250.00	1,682.05	4,100.00	5,961.96	18%	4	4	11	8
Weddings	8,000.00	9,229.92	16,000.00	14,658.22	44%	2	2	3	4
TOTALS	17,750.00	20,415.19	32,350.00	33,626.70	100%	63	46	91	69
COST OF SALES	5,810.00	5,964.65	9,675.00	9,472.20	28%				
GROSS PROFIT	11,940.00	14,450.54	22,675.00	24,154.50	72%				

GENERAL EXPENSES

	This Month Goal	This Month Actual	Year to Date Goal	Year to Date Actual	% of Sales
I Owner's Health Ins.	300.00	328.00	600.00	656.00	02%
Owner's Salary	3,000.00	3,000.00	6,000.00	6,000.00	18%
II Employee Expense	3,600.00	3,600.00	7,200.00	7,200.00	21%
III Outside Services	150.00	170.00	300.00	360.00	01%
IV Insurance	0.00	0.00	300.00	298.00	01%
Maintenance	50.00	0.00	100.00	794.56	02%
Property Tax	0.00	0.00	0.00	0.00	0%
Rent	1,000.00	1,000.00	2,000.00	2,000.00	06%
Utilities	150.00	169.00	350.00	383.00	01%
V Advertising	2,515.00	1,699.00	5,630.00	4,849.00	14%
VI Accounting/Legal	0.00	0.00	125.00	125.00	0%
Auto Expense	100.00	58.75	200.00	258.14	01%
Education Expense	0.00	0.00	1,200.00	1,375.00	04%
Interest	0.00	0.00	800.00	435.00	01%
Miscellaneous	20.00	37.50	40.00	37.50	0%
Office Expense	100.00	0.00	200.00	89.00	0%
Postage	40.00	38.00	80.00	105.00	0%
Props/Accessories	80.00	0.00	410.00	382.00	01%
Telephone	150.00	156.00	300.00	274.00	01%
VII Depreciation	500.00	500.00	1,000.00	1,000.00	03%
TOTAL EXPENSES	11,755.00	10,756.25	26,835.00	26,621.20	79%
NET PROFIT	185.00	3,694.29	-4,160.00	-2,466.70	-7%

I. Owner's Compensation
II. Employee Expense
III. Services you buy from people not on your payroll
IV. Overhead expenses associated with your place(s) of business
V. Costs associated with bringing business into your studio
VI. Administrative costs - cost of doing business in any location
VII. Depreciation

Owner's Compensation + Net Profit	4,189.30	12.45%

The Income & Expense Statement report shown at left is automatically produced from the sales and expense data entered into the software. It is your primary management document, as it posts actual business performance against the goals established in your Business Plan for sales, sessions, and expense areas. Presented in both monthly and year-to-date form, the report allows you to pinpoint the source of any shortfalls in performance. In this illustration, for example, Sales, Cost of Sales and General Expenses figures are all within budget; however session activity is below budget. When sessions are down, sales are likely to be lower than budgeted within the next several months, so marketing efforts must be reviewed and reinforced.

Source: Success Tracking application of SuccessWare® (800-593-3767)

The window at right shows another version of the same Income & Expense Statement, this time presenting Expense "Function Totals." Here, expense line items are grouped and summarized according to the functions their expenditures support. This allows you to monitor these areas not only by dollar totals, but also by their percentage of total sales. These percentages become an important measure of your performance in controlling expenses. Note that in both the window and in the report, "Owner's Compensation + Net Profit" are prominently displayed so that you are aware of the profitability of your business at any given time. Note also that Sessions are listed both numerically and as a percentage of total sessions, thus providing another important managerial measure.

Income & Expense Statement

February 1997 | **Year To Date**

Product Line	Receipts Goal	Actual	Pct.	Sessions Goal	Actual	Pct.
Frames/Accessory	0.00	0.00	0%	0	0	0%
Promotions	12,250.00	13,006.52	39%	75	57	83%
Seniors	0.00	0.00	0%	0	0	0%
Service Sessions	0.00	0.00	0%	2	0	0%
Studio Portraits	4,100.00	5,961.96	18%	11	8	12%
Weddings	16,000.00	14,658.22	44%	3	4	6%
TOTALS	32,350.00	33,626.70	100%	91	69	100%
COST OF SALES	9,675.00	9,472.20	28%			
GROSS PROFIT	22,675.00	24,154.50	72%			

Expense Function	Goal	Actual	Pct.
I Owner's Compensation	6,600.00	6,656.00	20%
II Employee Expense	7,200.00	7,200.00	21%
III Outside Services	300.00	360.00	1%
IV Location Overhead	2,750.00	3,475.56	10%
V Advertising	5,630.00	4,849.00	14%
VI Administrative Costs	3,355.00	3,080.64	9%
VII Depreciation	1,000.00	1,000.00	3%

I. Owner's Compensation
II. Employee Expense
III. Services you buy from people not on your payroll
IV. Overhead expenses associated with your place(s) of business
V. Costs associated with bringing business into your studio
VI. Administrative costs - cost of doing business in any location
VII. Depreciation

TOTAL EXPENSES	26,835.00	26,621.20	79%
NET PROFIT	-4,160.00	-2,466.70	-7%

Owner's Compensation + Net Profit	4,189.30	12.45%

Print | Change Month | Show Product Line | All | Show Expense Categories

Sales Averages

For all sessions.

Product Line Category	Number of Sessions	Total Sales	% of Total	Average Sale
TOTALS:	57	37,979.00	100%	666.30
Promotions	46	21,134.00	56%	459.43
"5 Ways"	8	4,256.00	11%	532.00
Bunny	29	12,058.00	32%	415.79
White Sale	9	4,820.00	13%	535.56
Studio Portraits	7	9,543.00	25%	1,363.29
Couples	1	1,200.00	3%	1,200.00
Families	6	8,343.00	22%	1,390.50
Weddings	4	7,302.00	19%	1,825.50

SuccessWare® also provides many other important automated reporting functions such as the Sales Averages and Sales Tax Reports shown at left and below.

Source: Success Tracking application of SuccessWare®
(800-593-3767)

Sales Tax Report

For receipts during February 1997.

State	Total Receipts	Exempt Receipts	Non-exempt Receipts	Taxes Collected
	1,431.00	1,431.00	0.00	0.00
PA	18,984.19	0.00	18,984.19	1,139.07

Monitoring Workflow

One of the biggest advantages of automated business management software is that it allows you to keep track of the various steps that each client order must progress through until the order is completed and filed. Order-tracking efficiency becomes important when a client calls to inquire about the status of a session or order; when you need to identify individual jobs that might be behind schedule; and to assure that you can retrieve filed negatives. Ensuring orderly operation is not the only reason to develop an efficient workflow system. Experience shows that the faster you

process orders through the business, the more business you are likely to acquire. Human nature makes us less aggressive about seeking new business as long as existing business is being processed. An efficient system is critical when it comes to assuring that clients are notified in a timely fashion to pick up finished orders and pay remaining balances due. As you process orders more efficiently, the more efficient you are likely to become at moving new business into your studio.

Sessions

Date	Session Number	Client Name	Product Line Category	Status As Of
			Service Sessions	Scheduled
2/23/97	10076	Kopec, Christopher	Publicity H&s	5/29/97
			Promotions	Scheduled
2/24/97	10060	Bray, Beth	White Sale	2/24/97
			Studio Portraits	Scheduled
2/25/97	10078	Kuntzleman, Ron	Families	5/29/97
			Promotions	Scheduled
3/2/97	10082	Himmelberger, Josh	"5 Ways"	2/23/97
			Promotions	Scheduled
3/3/97	10083	Smith, Tina	Bunny	2/5/97
			Studio Portraits	Scheduled
3/12/97	10077	Kopec, Christopher	Families	5/29/97
			Weddings	Scheduled
6/24/97	10025	Hoffman, Lynn		1/12/97
			Weddings	Scheduled
10/5/97	10073	Paulewitz, Amy		2/21/97

Sessions

Date	Session Number	Client Name	Product Line Category	Status As Of
			Studio Portraits	Previews ready
2/15/97	10074	Isom, Jack	Pets	2/27/97
			Promotions	Previews ready
2/17/97	10030	Caloiero, Cheryl	Bunny	2/27/97

These two "Sessions" reports illustrate how important "search" and "sort" capabilities are when monitoring workflow. In the first report, the software's "Sessions List" has been searched for those sessions that are currently scheduled. The second report shows current sessions in which the client's previews are ready to view. Any conceivable sessions, order status, or client identifier can be sorted in seconds, thus helping you to manage more efficiently.

Source: Success Tracking application of SuccessWare®
(800-593-3767)

Adding Prospects And Monitoring Inquires

Adding prospective clients to your mailing list for promotional mailings is an important marketing function. Prospects come from many sources, ranging from callers requesting studio information to names on purchased mailing lists. Integrated software provides the means of adding prospective clients to your data base as well as converting them to clients with a simple click of a mouse.

Recording information about inquiries can provide a wealth of data about the effectiveness of your in-bound telemarketing program. The telephone is the "front door" of your business, so telephone skills should be tracked, along with the marketing source that triggered the call. This way you can gauge the effectiveness of your marketing strategies in terms of the dollars they contribute to your business.

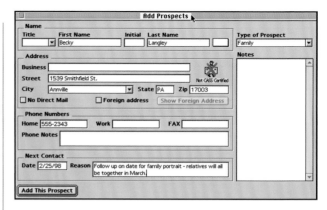

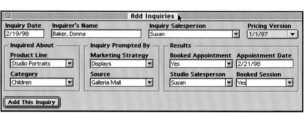

Inquiry Report

Inquiry Salesperson Product Line	Inquiries	Possible Inquiries	Booked Appt.	% Booked Appt.	Showed	No Shows	% Showed	Booked Session	% Booked of Showed	% Booked of Possible
TOTALS:	124	123	79	64%	70	9	89%	63	90%	51%
Helen	69	69	47	68%	41	6	87%	38	93%	55%
Promotions	59	59	39	66%	36	3	92%	36	100%	61%
Studio Portraits	6	6	4	67%	4	0	100%	2	50%	33%
Weddings	4	4	4	100%	1	3	25%	0	0%	0%
Susan	55	54	32	59%	29	3	91%	25	86%	46%
Promotions	49	48	28	58%	26	2	93%	23	88%	48%
Service Sessions	1	1	1	100%	1	0	100%	1	100%	100%
Studio Portraits	2	2	1	50%	1	0	100%	1	100%	50%
Weddings	3	3	2	67%	1	1	50%	0	0%	0%

Inquiry Sales Report

Marketing Strategy Source	Total Sales
TOTALS:	12,017.00
Client News	250.00
--NONE--	250.00
Direct Mail	1,967.00
Bunny Card	1,967.00
Displays	8,950.00
City Mall	3,464.00
Dr. Jones	1,650.00
Galleria Mall	3,836.00
Newspaper Ad	850.00
Old Town News	850.00
Word Of Mouth	0.00
--NONE--	0.00

In the two windows shown above, you can see how important prospect and inquiry information are quickly and easily added to your data base. The Inquiry Report above, which is generated by the information collected through the Inquiry window, compares the effectiveness of two employees in converting clients from telephone inquires, listed by specific product lines. The Inquiry Sales Report shown at left reveals the effectiveness of various marketing strategies and sources in terms of dollars of sales generated by each.

Source: Success Tracking application of SuccessWare®
(800-593-3767)

Managing People

(partial employment form, left side)

loyment

Phone (day) _____ (evening) _____

Social Security Number _____

s. Include dates:

How were you referred to us?_____

U.S. Citizen? _____ Under 17 or over 65?_____

jor Date Graduated

ctivities:

and where _____

As a company grows, the owner must learn to accomplish tasks through the efforts of others. For many business owners, hiring associates is an unfamiliar role. Nonetheless, the owner must learn how to recruit and retain dependable employees and to develop the leadership skills necessary to head a dynamic organization.

The People-Management Challenge

One of the great advantages of running a small business—as opposed to a large, bureaucratic organization—is that you do not have reams of regulations to adhere to when dealing with employees. Aside from government-mandated regulations, such as anti-discrimination statutes, you are free to design your own hiring and firing policies as well as those that deal with every-day business conduct. Sometimes, however, such freedom carries with it the burden of uncertainty over how best to handle personnel matters. A bad situation with an employee can cause at least as much organizational chaos and personal frustration for a business owner as serious financial problems. Understanding a few fundamentals about employee relations should help to eliminate personnel problems before they start.

The Importance of Good Employees

Although the primary mission of a photography business is to produce work of professional quality, the customer-service context in which the photographs are produced is as essential to the success of each business transaction as the quality of the images. In a photography business, the actions of every employee can add to or detract from the level of service your clients receive. That is why it is so important to hire and retain client-centered, service-oriented employees for all business functions. In your absence, your employees are your representatives. Everything they do reflects on both you and your business, therefore you must be confident of their ability to serve your clients well.

Staffing the Business

Listed below are key functional areas that a typical portrait/wedding photography business must staff. The list includes the personal qualities the employee who fills the position should possess, along with the areas of responsibility that the employee is likely to assume. In smaller studios, it often is necessary for one employee to perform duties in more than one of these functional areas and to assist in others. Before you hire anyone, make certain that you have clearly defined—on paper—exactly what you want the applicant to do and whether the job entails full-time or part-time work.

OFFICE MANAGER / PRODUCTION MANAGER

Personal Qualities—Responsibilities in this area require a well-organized, detail-oriented person who is a self-starter and who possesses above-average communications and people-handling skills, particularly when job responsibilities include managing the production of subordinates. The management style of the Office or Production Manager can set the tone of staff team-building, accountability, and civility attitudes that are so important to the success of a business.

Responsibilities
• Office workflow and/or production management
• Liaison between employees and owner regarding these issues
• Filing and record-keeping duties. This might include computer data input, income tracking, bank-account management and bill paying, if not done by a business manager.
• Assuring that building facilities are neat, clean, and properly maintained daily
• Training of subordinates

BUSINESS MANAGER

Personal Qualities—Responsibilities in this area require a well-organized, detail-oriented person who is qualified to design and implement business management systems and financial strategies.

Responsibilities
• Computer data input
• Income tracking and bank-account management
• Bill paying
• Business plan monitoring (both marketing and financial)
• Monitoring price levels
• Creation and execution of annual marketing plan, if not done by a Marketing/Promotions Manager
• Deal with personnel issues
• Conduct initial interviews to fill vacant positions and make recommendations to owner on what applicants he or she should meet personally for a second interview
• Maintain studio Policy Manual
• Liaison with owner regarding these issues

Often these responsibilities are assumed by the owner. When the owner decides to turn over any or all of these duties to a Business Manager, it is essential for the owner to continue to be aware of all managerial issues, particularly those that affect cash flow and client relations.

MARKETING/PROMOTIONS MANAGER

Personal Qualities—Responsibilities in this area require a person who is a creative self-starter and who is well trained in current marketing strategies.

Responsibilities
• Creation and execution of annual marketing plan, including:
 ~ Image-building marketing strategies
 ~ Income-producing promotional campaigns
• Liaison with staff so they are fully aware of marketing activities
• Team building with staff to gain their support for making marketing activities pay off

SALES/CUSTOMER SERVICE

Personal Qualities—Responsibilities in this area require a person who enjoys working with people, who has a pleasant appearance, possesses good communication skills, and who has a working knowledge of sales techniques.

Responsibilities

- Greeting clients/answering telephone
- Assuring that clients are properly prepared for the session
- Direct sales
- Client contact and follow-up as orders are produced

STAFF PHOTOGRAPHER

Personal Qualities—Responsibilities in this area require a person who enjoys working with people, has a strong work ethic, and who has working knowledge of photographic and darkroom techniques. A staff photographer must be capable of learning techniques and procedures from the owner or through educational events, so that he or she can be relied upon to photograph jobs as assigned.

Responsibilities

- Studio and location photography
- Inventory and monitoring of equipment
- Black-and-white processing and printing
- Color-negative processing
- Attend classes on new imaging techniques

Finding and Hiring Good Employees

The search for a good employee begins by clearly articulating what attributes are required for the position to be filled, so that an effective "want ad" can be created. Some experienced studio owners have found that a good source for office/production managers or sales people is their former clients. After all, they are already sold on the studio or they wouldn't have become clients in the first place. A letter sent to your client file, referring to the position you hope to fill, may be all the advertising you need.

Another avenue for filling positions in which customer service or sales is involved is through contacts you make in retailing situations. If you are particularly impressed by the "people skills" of a clerk who serves you in a retail establishment, let him or her know—in a discreet manner—that you are looking for someone with similar skills to fill a position in your business. The clerk might be looking for advancement, or he or she might know

A typical employment application is shown below.

Application for Employment

Name _____ Phone (day) _____ (evening) _____

Address _____

Length of stay at above address _____ Social Security Number _____

List previous addresses for last five years. Include dates:

Type of work desired_____

Salary requirements _____ How were you referred to us?_____

Date available for work _____ U.S. Citizen? _____ Under 17 or over 65?_____

EDUCATION Name & Address Major Date Graduated

High School _____

College _____

Graduate Work or Other _____

List scholastic honors, offices held, major activities:

Do you plan any further studies? If so, when and where _____

(over)

EMPLOYMENT RECORD

Starting with your most recent position, list previous three employers. Include self-employment, summer, and part-time positions.

Company _____

Address _____

Dates Employed: from _____ to _____ Highest Salary _____

Position a_____

Reason for leaving _____

Company _____

Address _____

Dates Employed: from _____ to _____ Highest Salary _____

Position a_____

Reason for leaving _____

Company _____

Address _____

Dates Employed: from _____ to _____ Highest Salary _____

Position a_____

Reason for leaving _____

Please read before signing: If you have any questions regarding this statement, ask them of the interviewer before signing.

In the event of my employment with this company, I will comply with the rules set forth in the Company Policy Manual.

I certify that all statements made by me on this application are true and complete to the best of my knowledge. I have withheld nothing that would, if disclosed, affect this application unfavorably.

(Signature) _____ (Date) _____

of someone else to recommend. Another source for new employees is business associates or local business owners.

Whether you follow one of these leads or pursue a classified advertisement in the newspaper, an interview is key to finding a qualified applicant. You can shorten the interview process by conducting a telephone interview as a first step. Usually this eliminates about half of the applicants. Send an application form to those who are still in the running, and schedule an interview time. A typical application form is shown on the previous page. If you have any questions about the civil rights implications of asking specific questions of prospective employees, call your local Chamber of Commerce to see if they can provide you with guidance and possibly some sample application forms.

The interview should be held in a relaxed atmosphere and broken down into two parts: In the first stage, determine if the applicant is a likely candidate for the job. If so, during the second stage you can explain more of the specifics of the job. If the candidate is not likely to be a suitable employee, then skip the second stage.

Among the important personal qualities to look for in a potential employee are the following: a desire to succeed, persuasiveness, humor, willingness to assume responsibility and to take chances, intelligence, optimism, good health, tact, and creativity.

During the interview process, take notes to use in evaluating the suitability of the applicants. The Interview Checklist and Interview Evaluation forms shown at right and on page 131 will help in accomplishing this task.

Before the job is offered, make sure that the applicant fully understands the responsibilities of the job and all terms of employment, including compensation and benefits. Each new employee

The Interview Checklist shown at right serves as a guide and rating device when conducting interviews with job applicants.

Interview Checklist

Name of Applicant _____ Date _____

Position Desired _____

Characteristics	Comments

Appearance
Cleanliness
Neatness
Grooming
Bearing and poise

Personality
Friendliness
Disposition
Sociability
Enthusiasm
Positive attitude
Ability to get along with others

Intelligence
Alertness
Ability to learn
Capacity to reason and think
Willingness to learn

Communication
Ability to listen
Pleasant voice
Vocabulary
Ability to express opinions and views

Maturity
Realistic
Knows his or her goals

Health
Last injury or illness
Attendance at previous position or school
Need of regular medical treatment

(over)

Characteristics	Comments

Ambition
Main needs - money, prestige, power, achievement
Realistic ambitions?

Education
Level
Subjects liked or disliked
Self-evaluation or worth of own education
Scholarships or academic awards
Extent of education self-financed
Activities and why chosen
Offices held
Relation to education and job

Work History
Substantial periods of unemployment
Progress demonstrated in work history
Reasons for changing jobs
Relation of previous jobs to job opening
Nature of previous work
Public contact involved in previous work
Extreme changes in job history
Likes and dislikes about previous jobs
Responsibility levels of previous jobs

Interest and Activities
Hobbies
Activities in community
Reading and other educational activities
Enjoyment of activities with large groups
Characteristics sought in choosing friends

How does applicant think he or she can assist this firm?

The Interview Evaluation shown below should be completed immediately after the conclusion of each applicant's interview. It will help in making your final selection from the pool of job applicants.

Interview Evaluation

Name of Applicant _____ Date _____

Position Desired _____

1. Does applicant have realistic understanding of the work requirement?

2. Does the applicant communicate clearly?

3. Does the applicant listen well?

4. Does the applicant appear to be congenial and friendly?

5. Does the applicant establish rapport easily?

6. Is the applicant frank and honest in response to questions?

7. Does the applicant appear to be in good physical condition?

8. Is the applicant motivated toward learning?

9. Does the applicant appear to be self-confident?

10. Is the applicant naturally curious and inquisitive?

11. Is the applicant honest and ethical?

12. Is the applicant alert?

13. Does the applicant demonstrate ambition?

14. Does the applicant give the impression of adaptability and flexibility?

15. Does the applicant appear to be capable of growth?

Consider hiring for position under these conditions:

Not suitable for present position, but consider for future openings:

should be given the Job Performance Evaluation shown at right. This form lists specific tasks that will be reviewed every three months for the first year of employment, with salary adjusted upward according to successful completion of each quarterly review. Both the employer and the employee should complete the evaluation. As part of the review meeting, the two can be compared and differences in perceptions of job performance discussed and reconciled.

Keeping Good Employees

Selecting a new employee is a very time-consuming process, so there is a lot at stake when you bring a new employee into your business. The success or failure in assuring that a good applicant becomes a good employee largely depends on your ability to

do two things: provide comprehensive job training and establish fair policies and clear objectives for your staff members.

UNDERSTANDING POLICIES

A new employee should become familiar with your firm's Policy Manual as soon as possible. Such a document is critical for effective personnel management. Creating a policy manual is a major management task that usually is not accomplished overnight. The job is made easier by working on it little by little. As an issue arises that should involve studio policy, make notes about it and file it in a loose-leaf binder. The documents will be there to consult until you have time to fill in the gaps. Among the policies that should be addressed are work hours, pay periods, overtime, vacations, personal conduct, and grounds for dismissal.

Employee Evaluation

Name _____ Job Title _____

Date _____

RATING

3 Month Review
duties/responsibilities: basic salary _____

poor	fair	good	excel.

6 Month Review
duties/responsibilities: basic salary _____

poor	fair	good	excel.

9 Month Review
duties/responsibilities: basic salary _____

poor	fair	good	excel.

12 Month Review
duties/responsibilities: basic salary _____

poor	fair	good	excel.

After each review, if employee has qualified in his or her job and has no "poor" ratings, he or she will move to next review section and the basic salary will apply.

The Employee Evaluation shown above helps to establish responsibilities and performance standards and is completed by both employee and employer once every quarter for the first year.

In addition to the policy manual, expect new employees to learn from the example you set in "values" areas such as service to clients, maintaining a standard for quality, dealing fairly with clients and employees, personal courtesy, and a positive outlook.

THE IMPORTANCE OF JOB TRAINING

As time-consuming as job training is, the alternative is wasted time, ruined supplies or equipment, the ill-will of clients who are not properly served, and the great likelihood that the new employee will never fit the job situation. So set aside time each day to review procedures personally with the new employee. Ask the employee to write down each procedure and file it in a Procedures Manual that can be used to train future employees.

Don't overwhelm the new person by expecting too much in too short a time. Generally, it is better for the trainee to master one task before moving on to the next. Offer praise when the job is done well, and act as a "coach," when making suggestions for improvement. Encourage the trainee to ask questions and to provide input on ways to improve procedures. Recognize that training is an on-going process that should involve all employees.

Becoming a Good Manager

Very few photographers go into business with the goal of being a good manager. As you add employees, however, it becomes your responsibility to create a positive working environment in your business by developing your associates' abilities and setting high leadership standards for yourself. The following guidelines will help to improve your people-management skills:

- Learn how to communicate with employees. Honest and open communication is necessary at all times. An employee cannot improve job performance if you do not honestly and fairly evaluate that performance.
- Say "thank-you" often and sincerely when tasks are completed.
- Learn to delegate. Employers often find it hard to trust others to do jobs they have mastered to perfection. Your business will never grow, however, unless you provide employees with a clear vision of what you expect them to accomplish. They may not do the job just as you would; so judge them on results, not on methods.

- Give employees the authority to act, and stand behind them when they do. The best employers are those who encourage risk. Nothing demoralizes employees like fear that the slightest failure could jeopardize their job. When mistakes are made, be supportive in your correction. By trusting your employees, they are much more likely to go out on a limb for you.
- Invite dissent. You are not getting what you pay for if your employees are afraid to speak up—particularly in areas where they might see room for improvement.
- Keep your cool in all situations, whether dealing with clients or with employees. The best leaders show grace under fire.
- Develop a vision and share that vision with employees. It is human nature for people to follow a person who knows where he's going. Let employees know how their participation in this "big picture" is essential if the vision is to succeed.
- Celebrate your successes with your staff. When you reach an important goal, have lunch catered or take your staff out. Courtesies such as this help to keep motivation and morale at a high level. Bigger accomplishments deserve bigger rewards.
- Treat employees like clients. Employees deserve the same respect you afford to clients whose goodwill you must depend on. Remember, your employees are your greatest asset—provided that you have hired the right people and trained them successfully.
- Consider incentive pay for employees. A profit-sharing or performance bonus is a good way of attracting and keeping qualified employees, motivating them to higher levels of performance, and allowing you to tie increases in pay to financial improvement. A bonus system goes into effect when a certain level of sales is achieved, with the employee(s) receiving the percentage-of-sale bonus on sales exceeding that level. Generally, the sales level is one in which the business reaches a certain level of profit, and typically the bonus is accounted and paid on a monthly basis.
- Be an expert. From boardroom to mail room, employees must appreciate that you know what you're talking about.

Managing Business Operations

No business becomes profitable and stays profitable without detailed planning and on-going management strategies. Many of these we have addressed in previous chapters. They include a year-round marketing plan, annual financial projections, pricing and sales strategies, and personnel management. They are the behind-the-scenes activities that provide structure to your business—activities that allow you to take control of the business so it can support both your artistic and financial goals. Ultimately, they assure the longevity of your business. Good management also requires addressing other operational issues that are covered in this chapter.

Managing Financial Affairs

In Chapter 9 you learned how to create and monitor a financial plan for the business, which includes reviewing the monthly Income & Expense Statement and the quarterly Balance Sheet. In addition to these important documents, you should be aware of several other indicators that measure the financial health of your business. These business measurement standards are expressed in the form of ratios, instead of numbers, and are calculated from numbers that appear on your Income & Expense Statement and Balance Sheet. Understanding these ratios will help you to make important management and planning decisions and assist in identifying any troublesome financial strains on the business by pointing out important trends that occur over time.

CURRENT RATIO

Current Ratio is calculated by dividing your Current Assets by your Current Liabilities. This ratio shows how capable your business is of meeting is Current Debt (debt that must be repaid within a year). Most lending institutions consider a 2-to-1 ratio as a safe relationship between assets and debt. This ratio is important to know if you are seeking a business loan. Figures for Current Assets and Current Liabilities are found on the Balance Sheet.

Net Worth To Debt

This ratio is calculated by dividing Net Worth by Total Debt. It determines how your personal investment in the business compares with the total amount due to creditors. A high debt ratio means the business is heavily financed and can be a financial warning sign. Net Worth and Debt figures are found on the Balance Sheet.

Net Profit To Total Sales

This ratio is calculated by dividing Net Profit by Total Sales. It determines what percentage of each dollar results in profit. The higher this percentage, the better your business is performing. Net Profit and Total Sales are found on the Income & Expense Statement. Remember, Owner's Compensation is a General Expense and not part of Net Profit.

Profit To Net Worth

This ratio is calculated by dividing Net Profit by Net Worth. It shows your return on investment, which should be at least as much as if you had invested elsewhere. By dividing this percentage into 100, you can calculate the number of years it will take to recapture your business investment. Net Profit is found on the Income & Expense Statement and Net Worth is found on the Balance Sheet.

Total Sales To Working Capital

This ratio is calculated by dividing sales by working capital. It shows how many dollars of sales the company makes for every dollar of working capital it has. When business is expanding, this ratio helps determine how much more working capital will be necessary to support higher sales. The figure for Total Sales is found on the Income & Expense Statement and Working Capital is determined by going to the Balance Sheet and calculating Current Assets less Current Liabilities.

Dun & Bradstreet, as well as some banking institutions, periodically publish average ratios for many types of business. However, it is difficult to determine such standards for photographers because business profiles vary so widely.

Financial Warning Signs

Most businesses, even well-run ones, experience ups and downs financially, so it is important to recognize certain warning signs that alert you to take corrective action before the problem becomes a crisis.

The monthly Income & Expense Statement is the primary tool for determining the financial position of your business. You should be concerned when you see sessions falling below their monthly and year-to-date goals. This indicates that your marketing activities are not paying off as they should. Other trouble signs are declining sales, profits, and working capital, and debt ratios that increase each month. All of these signs point to an existing or predictable cash-flow shortfall.

Ideally, you should have sufficient cash flow to support day-to-day activities, such as paying bills on time, to take advantage of early-payment discounts; to cover costs that grow out of an emergency situation; to allow the business to operate efficiently on credit—so there is no delay in ordering necessary supplies; and to extend credit to clients when appropriate.

The following are causes for a decline in working capital: Overinvestment in fixed assets, including paying for installment purchases ahead of schedule; paying high interest rates on borrowed funds; payment of unreasonably high salaries to the owner and/or employees; accumulating monthly losses; extension of too much credit to clients; and losses due to theft, litigation, or natural disaster.

Managing Credit

Nearly every business must, from time to time, rely on credit to finance capital expenditures or to sustain cash flow. It is important, however, to avoid the business pitfalls that imprudent uses of credit can cause. Among the common mistakes are:
• Buying something the business doesn't really need, just because credit is available.
• Using credit to purchase low-priority items, so that the credit limit is used up when it comes time to finance a purchase of major importance.

When this happens, either it is impossible to purchase the important item, or the business has to pay a higher than normal interest rate.

- Not understanding the full cost of the debt. When a business uses credit to purchase goods from suppliers, it forfeits access to trade discounts, usually two percent of the total purchase when the invoice is paid within ten days. Over the course of a year, this can amount to a substantial savings. Conversely, it adds significantly to the cost of credit when not used.

- Using short-term credit to make long-term investments. Be sure to delineate clearly the difference between a long-term loan and a "working-capital" loan. A long-term loan, as its name suggests, is used for financing long-term business assets, such as equipment, leasehold improvements, automobiles, and so forth. A working capital loan is used to finance temporary cash shortfalls and is repayable within a twelve-month cycle. When long-term debt is financed on a short-term loan, the cost of borrowing can rise significantly. Not only do interest rates on these two types of loans vary, the rates offered by different types of lending institutions vary as well. By selecting the right loan and the right lender for each purpose, a substantial reduction in financing costs can be achieved.

Most successful business people agree that small-business owners should borrow conservatively. The most important factor to keep in mind about borrowing is to do so only for the purpose of increasing profitability, not to make up for business losses.

Controlling Costs

A condition common to most businesses that experience financial difficulties is that they simply don't identify accurately all of the costs of doing business. In previous chapters we reviewed the three cost areas: Capital Expenses, Cost of Sales, and General Expenses. Controlling costs will be much easier if you fully understand the categories for each of the three classifications, as well as recognize what types of expenses are accounted under each of the categories. If you have any questions about the three classifications,

their categories, and the expense items belonging to each, review the information appearing on pages 26 (Capital Expenses), 80 (Cost of Sales), and 108-110 (General Expenses).

Even though you might have a business manager or office manager who records your income and pays your bills, you should look over monthly bills before they are paid to see if the expenses are within the budget set up as part of your annual financial plan. In addition, you should check on Accounts Receivable to assure that appropriate collection procedures are going forward. Also, review your expenses once again, as part of the monthly review of your business plan, at which time you also examine performance in income and session areas.

Inventory Purchasing and Control

Inventories have been called the "graveyard of business," because excessive or improperly managed inventories so often lead to business failure. The key to inventory management in a photography studio is to carry the minimum inventory necessary to service clients satisfactorily. That way you don't lose a sale because an item isn't available, but at the same time you don't tie up working capital by keeping an excessive number of items on hand.

Inventory is not a major problem for photographic studios, because today most do not process their own color negatives and prints in-house. Keeping adequate inventories of chemistry and paper adds greatly to the complexity of running a photography business and typically is not cost-effective. That leaves film, frames, folders, packaging materials, and wedding albums as the major inventory items for most studios. For these items, the rule of thumb is to keep on hand only the quantity of items you expect to use within a three-month period. This way you will be paying for items used with money generated by items sold and not tying up funds needed to pay your firm's General Expenses. When you reduce inventories, you might possibly free up storage space that could be used to generate additional income through the creation of a specialty camera room or sales area.

It pays to develop good relations with suppliers so that you can count on them to go out of their way to help fulfill orders—particularly at peak times. Also, some suppliers can provide helpful advice on how to make the most of their products.

Workflow Management

KEEPING TRACK OF WORKFLOW

Keeping track of the progress of your clients' orders can be a nightmare if you don't have a well-organized system to track each individual order through the various steps of manufacture and filing. You will need such a system to pinpoint where a job stands should a client call to inquire about its status, to identify individual jobs that might be behind schedule, and to assure that you can retrieve filed negatives should they be needed for future reference. Today, computers make this task much easier than in the past, when order tracking was done entirely by hand.

Each month you should examine a computer printout to determine if film processing, order previewing, and orders at the lab are progressing on schedule. Then you can take appropriate action if they are not. You also can total the unpaid balances of all orders in process or Accounts Receivable and even do sales projections on the jobs for which the photography has been completed. These totals will help you to forecast future cash flow.

COLLECTING PAST-DUE ACCOUNTS

One of the most important functions of the order-tracking process is making sure that finished work is picked up and paid for promptly. Proper handling of past-due accounts, as suggested below, will help you to collect unpaid balances efficiently.

Two weeks after notifying a client that his order is completed, send a statement that advises:

> In case you missed our first notification, please be advised that your order is completed. To avoid having to pay interest on the unpaid balance of your order, please make your final payment within two weeks.

Thirty days later, send a statement with interest added and the following notation:

> Please check your records, and if this bill has not as yet been paid, send us a check or credit-card payment for the amount indicated. If there is any problem with your account as shown, please contact us immediately.

Thirty days later, send a statement with additional interest added and the following notation:

> This statement shows your account to be sixty days overdue. Since we have not heard from you, we assume that there is no problem with the amount of the bill or the services you received from us. Please give this matter your immediate attention.

Thirty days later, send (by certified mail) a statement with additional interest added and the following notation:

> This is your third and final notice regarding your overdue account. Unless payment is received within ten days, this matter will be turned over to a District Justice for collection. The District Justice is empowered to issue a judgement against you and to seize property for sale in order to satisfy the amount owed to us. You can avoid this action by contacting us immediately and arranging to make payment.

If payment is not rendered within ten days, then take action through your local government's appropriate judicial office. Be sure to keep duplicate copies of all statements sent so that you can show authorities you have made a good-faith effort at collection. This record of your correspondence with the client also will protect you from any attempt by the client to countersue you for harassment. Recognize that the longer an account goes unpaid, the less chance you have to make collection, so by adhering to this collection schedule, you are likely to have few bad debts. If you have a client who is experiencing a financial problem but who makes a good-faith effort to make payments each month, it is perfectly acceptable to allow reasonable terms of repayment—without interest—if you so desire.

Managing Records and Files

Maintaining files and records of your business transactions is a distinctly unglamorous side of the photography business, but it is as necessary as maintaining your camera equipment. Should your business be audited by IRS or by the state, you will be required to produce income and expense records, including receipts to document every expense transaction claimed during the year under audit. Therefore, it is necessary to maintain an alphabetical file of expense receipts on a yearly basis. Your accountant can advise you as to the number of years these receipts should be stored. You must also store cancelled checks, petty-cash records, records of capital expenditures, loan repayments, tax returns, employee tax records, depreciation schedules, and inventory lists. If possible, these files and records should be kept in a fireproof safe.

Other important papers, such as articles of incorporation or business contracts, should be kept in a bank safety-deposit box. It is also wise to keep back-up computer disks of important client information and other management files in a location other than your business, updating these back-up files on a regular basis. The very survival of your business could depend on having these data files available to you in the event of a fire or other disaster that might destroy your business facility.

Similarly, you should consider how to safeguard client negatives. In addition to following the film manufacturer's recommendations for storing the negatives, you might consider keeping a negative file of some of your favorite images in a location other than your place of business. In the event of a disaster to your building, you will have a collection of images to use as samples.

Working With Outside Services

Sometimes it pays to use the services of people who are not on your payroll to perform tasks for your business. Such services include trash removal, janitorial services, and grounds maintenance. The advantage to using such services is that you are paying a set fee for the services at a set time.

This helps to assure that the tasks are accomplished. You are the client of the service, and the business owner must provide that service or face being fired. If you have an employee do any of these jobs, you risk not getting the tasks accomplished in a timely manner during peak business periods. In most cases, your employees are more valuable doing income-producing jobs than attending to these chores.

Even if you have a business manager or office manager who takes care of your accounting chores, you may want to retain an accounting service to review your monthly reports, maintain your payroll records, prepare monthly tax returns, and file your income taxes. Another good reason to have an accounting service as a backup for your internal record keeping is that the service provider can represent you in the case of a tax audit at little or no additional cost to your business. When selecting an accounting service, ask for a clarification of the firm's role in tax audits.

If you decide to use an outside firm to assist with accounting, you are not relieved of the responsibility of reviewing your financial records and tax transactions. It is essential to keep your finger on the pulse of your finances at all times.

Working With a Professional Lab

A studio is only as good as the photo-finishing laboratory that backs it up. In many ways, the relationship you build with your lab is like a "marriage" that must be nurtured. Among the characteristics of a quality lab are consistency of color and density of prints, good turnaround time, services offered, a toll-free telephone number, and reliable customer service.

Once you find a lab that you like, stick with it. Use the telephone frequently to communicate with customer service. Get to know key lab employees by name and build a personal working relationship with them. No lab is perfect, so when you detect a problem—no matter how small—report it. Over time, the better you communicate, the better the lab will be in serving your business and artistic needs.

around with the vague discomfort that comes when you are concerned about forgetting something important. Then rank tasks you've written down in order of their importance to your business objectives. Prepare schedules and checklists of things to be done—daily, weekly, and monthly. Rearrange them until it seems you have planned your time wisely. Be flexible, but make certain that you accomplish the most important tasks first.

Problem Solving

The ability to solve problems is one of the hallmarks of a good manager and a good leader. You can improve your problem-solving ability by following these steps:

• Define the problem. State succinctly what the problem is and what impact it is having on your business.

• Consider possible solutions. Write down all of the possible courses of action to take.

• Decide on the best solution and test it.

• Evaluate the success or shortcomings of the solution. If necessary, resume the testing procedure.

• Once you have identified the best solution, refine it and continue with its implementation.

Deciding on New Products or Services

The stability of your business depends on making changes in an orderly fashion. When considering the addition of new products or services, it is helpful to pose the following questions:

• What is the benefit of the product or service to the consumer?

• Will the product or service give us an advantage over our competitors?

• Will the benefit be easily identified by the consumer, or will client education be necessary. If so, what form will that education take?

• What type and frequency of advertising will be necessary to market the product?

• How will the new product or service affect the activities of staff members?

• Must any new systems be designed and implemented to support the product or service?

• Given the price of the new product or service and its Cost of Sales, will it be profitable, and what is the likely impact on increased Gross Sales and Net Profit?

• When should the success of the new product or service be evaluated?

Understanding the Business Cycle

Like people, businesses are subject to a "life cycle." If you understand the nature of that life cycle, it will help you to manage it successfully. Following is a brief description of the business life cycle and its characteristics:

INFANCY — The business struggles to get on its feet. The owner's excitement—and often anxiety—run high as all energies are directed toward getting the business off the ground. Often mistakes are made, and valuable experience is gained.

ADOLESCENCE — The business still struggles, but hard-earned experience is beginning to pay off. The owner's confidence builds as more things go right than go wrong, although lack of experience still leaves the business open to serious challenges.

ADULTHOOD — For the owner, this is one of the most satisfying times in the life cycle of the business. Successful adulthood means that the business is now profitable, the owner is experienced in managing all aspects of the business and is comfortable in the role, the business has achieved a loyal client base, and it is held in high esteem in the community. Competitors are now likely to emulate many of the successful programs developed by the business in an effort to gain their share of a market that the adult business has successfully cultivated.

OLD AGE AND DECLINE — The business has ceased being innovative and has relied on past ways of doing business that might no longer be relevant to today's market. Instead of attracting new clients through "low-commitment" products that helped the business to gain clients during its infancy and adolescence, the business relies on the existing client base that inevitably shrinks through normal

attrition and the success of competitors. Customer service often drops off, the owner's passion for the business is no longer as acute, and even increased promotion does not seem to bring increased business.

When a business falls victim to the old-age and decline stage of the business cycle, it is very difficult for it to recover without virtually "reinventing" itself. This involves establishing a new image that is relevant to current market conditions and offering products—including low-commitment specials—that help to attract new business.

As a manager, your best strategy, of course, is to prevent the business from entering old-age by continually enhancing business image, introducing new products, emphasizing customer service, and executing and monitoring the results of a comprehensive marketing program that is based on up-to-date marketing concepts and strategies.

Conducting Staff Meetings

The weekly staff meeting is the cornerstone of short-term planning. Be prepared to meet with your staff at a set time each week during a period when the business is not open to receive customers. A well run routine staff meeting should take no more than an hour. An agenda should be set in advance and include such items as a review of the firm's current financial position, based on yearly projections; a similar review of current expense performance; a review of current and up-coming promotions; and a discussion of any current problems, such as orders that are behind schedule, dissatisfied clients, and the like. Any items requiring action should be clearly assigned to a specific staff person, along with a date by which the action is to be accomplished. A review of this action should become part of the next meeting agenda.

The key to effective short-term management is to attack one problem (or an aspect of the problem) at a time, making use of existing staff and resources. This technique should be adhered to at your staff meetings. Define and solve that problem first, and then move on to the next. This approach guarantees progress over the long term and prevents you from going off to look for expensive solutions, such as hiring additional staff or acquiring expensive equipment, when neither is needed. For example, a manager who believes that she needs additional working or storage space may actually need to throw away useless clutter that is occupying valuable space.

Allow employees to participate in the annual planning process. When you do, you will find they are much more likely to want to help make the plan succeed, because they are at least partially responsible for setting its goals.

Consulting With Business Advisors

With business growth comes change, and sometimes change can lead you into areas where your business experience may not be broad enough to recognize potential hazards or opportunities. That is why you should meet once a year with experienced business advisors. They can include your accountant, banker, attorney, business consultant, and/or another photographer who has demonstrated a long-standing record of business success. They can assist you with such important matters as deciding what type of business entity (sole proprietorship, partnership, or corporation) your firm should assume, given its current financial position. An insurance planner can inform you of opportunities for personal insurance protection, such as health, life, income protection, and retirement plans that are deductible as business expenses.

Financial planners predict that for today's young person to retire comfortably, it will take a million dollar investment. Statistics show that only a very small percentage of the population is financially able to retire. Therefore, make sure that your business plan includes provisions for sufficient income to be invested in a solid retirement plan.

Planning for the Sale of Your Business

The day will come when you are ready to sell your business and retire. Good advance planning can maximize the asset value of your business. A period

of good earnings, for example, will increase the net asset value. Because earnings can be enhanced by such means as slowing down depreciation and limiting capital spending, by planning ahead you can produce a Balance Sheet that enhances the value of the company. Ideally, you will want to dispose of your business at a time of economic prosperity.

Planning for the eventual sale of your business is particularly critical when a member or members of your family are involved in the business. Far too many families become bitterly divided when business assets are part of an estate dispute between children who have worked in the family business and those who have not. Provisions must be made for the orderly disposition of the business in the event of an estate settlement. This can be accomplished through proper estate planning, stock transactions, and insurance protection; and such strategy is one of the most important matters to be addressed by your business advisors in formulating your overall business plan.

Continuing Education

Technology will continue to change the way you run your business and how you interact with clients. Only through continuing education can you stay at the forefront of technology and remain ahead of competitors.

Part of your continuing education should be in the area of leadership. Leadership begins with knowledge. Your ability to lead improves as you become knowledgeable about a host of subjects including finance, markets, economics, personnel, etc. You can increase your knowledge of these subjects by reading publications such as *The Wall Street Journal, Business Week, Boardroom Reports, U.S. News and World Report, Advertising Age, Success, Fortune, Forbes, Money,* and *Inc.*

Other learning opportunities are available through business courses at local community colleges or your local Chamber of Commerce. Active participation in professional associations such as the Professional Photographers of America and its state and local affiliates is essential if you are to keep up with new technologies and market trends

specific to photography. Participation as a committee chairman or officer in these groups also provides opportunities to develop additional leadership skills.

Looking to the Future

If you are new to the business of photography and have taken the time to read this book, it may seem that building a successful business is a very daunting task. Even if you have been in business for several years, you might not as yet be satisfied with the level of success you have achieved.

While it is true that achieving success takes a great deal of time and effort (and often money), you should recognize that no business is "built in a day." In fact, building, nurturing, and sustaining a business is a process that is on-going during the entire life of the business. The process is greatly facilitated by understanding the elements that go into achieving success in the business of photography.

No book, seminar, or course of study can assure business success. However, if you spend time converting the information presented here into a plan of action, then you will have taken a positive step toward establishing a business that can satisfy both your artistic visions and your financial goals.

Appendix

MARKETING AND MANAGEMENT PRODUCTS AND INFORMATION:

Marathon Press, Inc.
1500 Square Turn Blvd.
P.O. Box 407
Norfolk, NE 68701
(800) 228-0629
Fax: (402) 371-9382
Web Site: www.marathonpress.com
e-mail: contact@marathonpress.com

INDUSTRY-SPECIFIC STUDIO MANAGEMENT SOFTWARE:

SuccessWare®
3976 Chain Bridge Rd.
Fairfax, VA 22030
(800) 593-3767
Fax: (703) 352-0537
Web Site: www.successware.net
e-mail: info@successware.net

ALBUM-PRESENTATION SOFTWARE, ALBUMS, FOLIOS

Art Leather
45-10 94th St.
Elmhurst, NY 11373-2824
(718) 699-9696
Fax: (800) 88ALBUM
Web Site: www.artleather.com

ACCOUNTING SERVICE

Century Small Business Solutions
26722 Plaza Drive
Mission Viejo, CA 92691
(800) 323-9009
www.centurysmallbiz.com

FILING MATERIALS AND FORMS

New England Business Service, Inc.
500 Main St.
Groton, Massachusetts 01471
(978) 597-8715
Customer Service: (800) 225-9540
To Order: (800) 225-6380

APEC (American Printing & Envelope Co.)
900 Broadway
New York, NY 10003
(212) 475-1204

PROFESSIONAL ASSOCIATION

Professional Photographers of America
229 Peachtree Street
Suite 2200, International Tower
Atlanta, GA 30303
(800) 786-6277
Fax: (404) 614-6400
Web Site: www.ppa-world.org